soho theatre

W9-BYH-202

Soho Theatre and Akbar Kurtha present

Baghdad Wedding
by Hassan Abdulrazzak

First performed at Soho Theatre on 28 June 2007

Soho Theatre is supported by

TEQUILA\
LONDON

Bloomberg

Supported by
City of Westminster

phf

JOHN
LYON'S
CHARITY

Harold Hyam
Wingate
Foundation

CITY
OF
LONDON

Performances in the Lorenz Auditorium
Registered Charity No: 267234

Soho Theatre and Akbar Kurtha present

Baghdad Wedding
by **Hassan Abdulrazzak**

Kathum	**Silas Carson**
Ibraheem / Boothe	**Emilio Doorgasingh**
Melissa	**Annie Hemingway**
Yasser / Sayef	**Cosh Omar**
Salim	**Matt Rawle**
Luma	**Sirine Saba**
Marwan	**Nitzan Sharron**
Omar / Nadir	**Rohan Siva**

Director	**Lisa Goldman**
Designer & Costume Designer	**Jon Bausor**
Lighting Designer	**Jenny Kagan**
Sound Designer	**Matt McKenzie**
Assistant Director	**Will Mortimer**
Fight Director	**Brett Yount**
Dialect Coach	**William Conacher**
Composer	**Keith Clouston**
Percussion & Dance	**Tim Garside**
Production Manager	**Matt Noddings**
Stage Manager	**Dani Youngman**
Deputy Stage Manager	**Fiona Proffitt**
Assistant Stage Manager	**Natasha Emma Jones**
Wardrobe Supervisor	**Sallyann Dicksee**
Casting	**Nadine Hoare**

Head Technician	**Nick Blount**
Head of Lighting	**Christoph Wagner**
Scenery built and painted by	**Visual Scene**

Press Representation	**Nancy Poole** (020 7478 0142)

Thank you to Irene East, Gary Davy, Andrew Steggall, James Mann, and to everyone who helped in the workshop process of Baghdad Wedding.

Soho Theatre, 21 Dean Street, London W1D 3NE
Admin: 020 7287 5060 Fax: 020 7287 5061 Box Office: 0870 429 6883
www.sohotheatre.com

Writer

Hassan Abdulrazzak

Hassan Abdulrazzak holds a PhD in Molecular Biology. He works as a postdoctoral researcher at Imperial College. In 2006, he co-organised the Iraqi Documentary Film Festival at the School of Oriental and African Studies (SOAS). *Baghdad Wedding* is his first play.

Cast

Silas Carson
Kathum

Theatre credits include: *Macbeth* (Almeida Theatre); *Homebody/Kabul* (Young Vic/Cheek By Jowl); *A View From The Bridge* (Sheffield Crucible); *Shakuntala* (The Gate Theatre); *A Doll's House* (Young Vic Theatre); *Romeo and Juliet* (Lyric Theatre, Hammersmith); *Crossfire* (Paines Plough Tour); *Heer Ranjha* (Tara Arts Tour); *Unidentified Human Remains* (Traverse & Hampstead Theatre); *Taming of the Shrew* (Royal Lyceum Theatre, Edinburgh); *The Lover* (Traverse Theatre); *Romeo and Juliet* (Royal Lyceum Theatre, Edinburgh); *Twelfth Night* (Playhouse Theatre, London). Television credits include: *The Chase*; *The IT Crowd*; *Warriors*; *The Bill*; *Fear, Stress and Anger*; *Hustle*; *The Ten Commandments*; *Spooks*; *Coronation Street*; *Absolute Power*; *William and Mary*; *The Grid*; *Lie With Me*; *Waking the Dead*; *The Project*; *A & E*; *Metrosexuality*; *Innocents*; *An Unsuitable Job For A Woman*; *Cold Lazarus*; *Supply and Demand*; *The Golden Years* (Channel 4). Film credits include: *Flawless*; *Chromaphobia*; *Hidalgo*; *Star Wars Trilogy*; *Josephine*; *Jeremiah*; *Feverpitch*; *Saving Grace*.

Emilio Doorgasingh
Ibraheem / Boothe

Theatre credits include: *Salt Meets Wound* (Theatre 503); *How Many Miles To Basra* (West Yorkshire Playhouse); *Angels Among The Trees* (Nottingham Playhouse); for Edward Hall's Propeller Company: *A Midsummer Night's Dream* (Comedy Theatre/International Tour); *Rose Rage* (Haymarket Theatre/International Tour); *Twelfth Night* (Watermill Theatre); *The Comedy Of Errors/Henry V* (Watermill Theatre/International Tour); *Change of Heart* (New End Theatre); *The Ramayana* (Royal National Theatre); *Dial M For Murder* (English Theatre of Frankfurt); *The Middle Class Tendency* (Wimbledon Theatre); *The Magic Toyshop* (UK Tour); *Saying Yes* (The Gate); *Dreams Of Clytemnestra* (BAC); *Cymbeline* (Etcetera Theatre). Television credits include: *The Path To 9/11*; *Hannibal*; *Miss Marple*; *Rebus*; *The Bill*; *Neanderthal*; *David (The Bible)*; *Anton And Minty*; *Uncle Jack and Cleopatra's Mummy*. Film credits include: *Rendition*; *Kingdom Of Heaven*; *Guru in Seven*.

Annie Hemingway
Melissa

Annie trained at RADA. Theatre at RADA include: *Ghosts, Titus Andronicus, Odysseus, Through The Shadows With O'Henry, The Duchess Of Malfi, Trelawney Of The Wells, Richard III, Machinal, The Double Dealer, The Girl On The Sofa, Barbarians*. Other theatre include: *Chorus In Murder* (National Youth Theatre); *Electra* (Theatre Royal Bath). Radio credits include: *Kamikaze Handbook* (Radio 4).

Cosh Omar
Yasser / Sayef

Theatre credits include: *The Battle of Green Lanes* (Theatre Royal Stratford East); *Macbeth, 100, A Midsummer Nights Dream, Rosencrantz and Guildenstern Are Dead, Shrewd* (Arcola

Theatre); *Murder* (Gate Theatre); *Snow White* (Wimbledon Theatre); *Writing on the Wall* (Arts without Borders); *The Trial of Joe K* (Foxglove Theatre Company); *The Wonderful Wizard of Oz* (Edinburgh Festival); *Winners* (The Moon Theatre); *The Comedy of Errors* (Theatre Museum); *Sweeney Todd* (Bloomsbury Theatre). Television credits include: *The Bill*; *Bleak House*; *EastEnders*; *Murder Prevention, Spooks 3, Ultimate Force, Neanderthal's World, The Fast Show, Gulliver's Travels*. Film credits include: *Walls of Silence; Turkish Coffee; SW9; Saturday Night Feeling; Chicago Joe and the Showgirl*.

Matt Rawle
Salim

Matt trained at Mountview Theatre School. Theatre credits include: *Evita* (Adelphi Theatre); *Assasins* (Sheffield Crucible), *To Be A Star* (Qatar Centre Excellence) *Martin Guerre* (Prince Edward Theatre); *Miss Saigon* (Theatre Royal Drury Lane); *Into The Woods* (Donmar Warehouse); *Hard Times* (Theatre Royal Haymarket); *Camelot, A Midsummer Night's Dream* (Open Air Theatre Regent's Park); *Alice In Wonderland* (Bristol Old Vic); *Les Miserables* (National UK tour and Denmark); *Carmen* (Tour); *Putting It Together* (Chichester); *Mother Goose* (Theatre Royal Norwich); *Hello Again* (Bridewell Theatre); *Treasure Island* (Lyric Hammersmith), *The Go Between* (Pleasance Theatre), *South Pacific* (Grange Park Opera), *Almost Like Being In Love* (National Theatre), *Mother Claps Molly House* (National Theatre Studio).

Sirine Saba
Luma

Theatre credits include: *Taming of the Shrew, A Midsummer Night's Dream, Twelfth Night, HMS Pinafore* (Open Air Theatre Regent's Park); *Beauty and The Beast, Midnight's Children, The Tempest, The Winter's Tale, Pericles* (RSC); *Cinderella* (Bristol Old Vic); *Our Town, The Pillars of Society* (RNT Studio); *House & Garden* (Northampton); *Sparkleshark* (RNT Tour); *A Warwickshire Testimony, Tales from Ovid, A Midsummer Night's Dream* (RSC); *Soho* (RSC Fringe); *The King and I* (BAC); *Paper Husband* (Rosemary Branch). Television credits include: *Silent Witness; Footballers' Wives; The Bill; Prometheus*. Film credits include: *Death of the Revolution (Short); Do's and Don'ts*. Radio credit: *Love and Loss*.

Nitzan Sharron
Marwan

Theatre credits include: *2000 Years, Sparkleshark* (National Theatre); *Crazy blackmotherf**ckin'self, Baazar* (Royal Court); *Henry IV* (Donmar Warehouse); *The Jew of Malta* (Almeida); *Cause Célèbre* (Lyric Hammersmith); *Chicken Soup With Barley, Ritual in Blood* (Nottingham Playhouse); *A Phoenix Too Frequent, Angels* (Salisbury); *A Thought in Three Parts* (BAC), *Treehouses* (Northcott, Exeter); *Waiting For Godot* (Contact); *The Day the Bronx Died* (Tricycle Theatre); *Shadowlands* (Queens); *Les Liaisons Dangereuses* (Frankfurt). Television credits include: *Nuclear Race; Holby City; The Bill; Daniel Deronda; McCallum; Broken Glass; Dangerfield; Grange Hill; Bad Boyz; Space Precinct; Harry's Mad; Love Hurts; My Secret Summer; Mike & Angelo*. Film credits include: *The Gospel According to St John; Devil's Arithmetic; Simon Magus; Christopher Columbus: The Discovery; That Summer of White Roses*. Radio credits include: *Mothers, Daughters and Chicken Soup; Toad; Penny Gold; Memorial Candles: A Strange Legacy* (BBC Radio).

Rohan Siva
Omar / Nadir

Rohan trained at the Royal Academy of Dramatic Arts. Theatre credits include: *Life of Galileo* (Birmingham Rep); *Julius Caesar* directed by Deborah Warner (Barbican Theatre); *The Country Wife*

(Watford Palace Theatre); *Henry V* directed by Nicholas Hynter (Royal National Theatre); *The Taming of The Shrew* (Salisbury Playhouse); *A Perfect Ganesh* (Palace Theatre Watford); *The Misanthrope* (Chichester Festival Theatre); Laertes in *Hamlet* directed by Peter Brook (CICT/International Tour); *Romeo and Juliet* (Leicester Haymarket); *Arabian Nights* directed by Dominic Cooke (Young Vic/ UK Tour). Television credits include: *The Bill*; *Holy Cross*; *Single*; *Holby City*. Film credits include: *Outlaw* (Vertigo Films); *Hawking* (BBC); *Final Curtain* (DNA); *Hamlet* (AGAT Films). Radio credits include: *Paradise*; *The Salt March*; *Arabian Nights*

Company

Lisa Goldman
Director

Lisa is the new Artistic Director of Soho Theatre and *Baghdad Wedding* is her second show in this role, following on from the success of *Leaves of Glass*. As founding Artistic Director of the Red Room, Lisa developed and directed a huge body of radical new writing over 10 years. Her production *Hoxton Story,* was a site-specific walkabout piece which she wrote and directed. Other recent new plays developed and directed include *The Bogus Woman* (Fringe First- Bush/Traverse/tour/Radio 3 Sunday play), *Bites* (Bush Theatre) and *Animal* (Soho Theatre), *Hanging* (CBL Radio 4 Friday play) all by Kay Adshead, curating *Going Public* (Tricycle Theatre), *Playing Fields* by Neela Dolezalova (Soho Theatre Company), *Made in England* by Parv Bancil, *Sunspots, Know Your Rights* and *People on the River* all by Judy Upton. *Ex, Obsession* and *Surfing* (Critics' Choice BAC) and a 35mm short film *My Sky is Big* (NFT 1 & festivals) all by Rob Young. Lisa's long term producing collaboration with Anthony Neilson has enabled the creation

of some of his finest work – *The Censor, Stitching* (both Time Out Live Award winners) and *The Night Before Christmas*. In 2001 Lisa co-founded Artists Against the War.

Jon Bausor
Designer & Costume Designer

Jon read Music as a choral scholar at Oxford University and Fine Art at Exeter College of Art before training on the Motley Theatre Design Course. He was a finalist in The Linbury Prize. Theatre designs include *Julius Caesar, Terminus* (Abbey Theatre, Dublin); *Scenes From The Back Of Beyond* (Royal Court); *The Soldier's Tale* (Old Vic); *Notes From Underground* (West End); *James and the Giant Peach* (Octagon Theatre, Bolton); *The Great Highway* (Gate Theatre, London); *Cymbeline, Macbeth* (Regent's Park Open Air Theatre); *Frankenstein* (Derby Playhouse); *Shrieks of Laughter* (Soho Theatre); *The New Tenant, Interior, The Exception And The Rule, Winners and The Soul Of Chien-nu* (Young Vic); *Bread And Butter* (Tricycle); *Carver* (Arcola Theatre); *The Last Waltz season* (Oxford Stage Company); *Melody, In The Bag* (Traverse); *Sanctuary, The Tempest* (Royal National Theatre) and *The Taming Of The Shrew* (Thelma Holt /Theatre Royal, Plymouth). Dance designs include *Snow White In Black* (Phoenix Dance Theatre-Dance Critics Circle award); *Echo and Narcissus, Ghosts, Before The Tempest, Sophie, Stateless and Asyla* (Linbury Theatre, Royal Opera House); *Mixtures,* (English National Ballet); *Non Exeunt* (George Piper Dances/ Sadler's Wells), and *Marjorie's World Unhinged* (Tilted). Opera design includes *The Knot Garden* (Klangbogen Festival, Vienna); *The Queen Of Spades* (Edinburgh Festival Theatre), *Cosi Fan Tutte* (Handmade Opera), and *King Arthur* (New Chamber Opera). Forthcoming work includes a new version of the Stravinsky ballet *Firebird* (Bern Ballet, Switzerland), *Nightime* (Traverse), *The Lighthouse*

(Poliziano, Montelpuciano) and a new devised piece for Filter, entitled *Water* (Lyric, Hammersmith).

Jenny Kagan
Lighting Designer

Jenny trained as an actress and worked as a stage manager before turning to lighting design. Productions include: *Pan* (Capitol Theatre Sydney), *Sacred Ellington* performed by Jessye Norman (Barbican Centre), *Who's Afraid Of Virginia Woolf* (Almeida and Aldwych Theatre), *Oliver!* (Australian, US and UK Tours), *Elisir d'Amour* (New Zealand Festival) and the recent UK tour of *Miss Saigon*. She worked with David Hersey on *Piaf*, *The Seagull*, *Martin Guerre*, *Jesus Christ Superstar*, *Les Misérables* (UK tour, Sydney, Antwerp and Dublin). She was Associate Lighting Designer for *Oklahoma* (RNT, West End, Broadway & Primetime Films) and has also worked on shows at The Bush, Tricycle, West Yorkshire Playhouse and Edinburgh Lyceum. Recently she worked with Lisa Goldman on *Leaves of Glass* (Soho Theatre), *The Hoxton Story* for the Red Room and *Bites* (Bush Theatre).

Matt McKenzie
Sound Designer

Matt McKenzie came to the UK from New Zealand in 1978. He toured with Paines Plough before joining the staff at The Lyric Theatre Hammersmith in 1979 where he designed the sound for several productions. Since joining Autograph in 1984, Matt has been responsible for the sound design for the opening of Soho Theatre along with its productions of *Leaves of Glass, Blue Eyes and Heels, Badnuff; Vertigo* (Guildford); *Saturday, Sunday, Monday, Easy Virtue* (Chichester); *Frame 312* (Donmar Warehouse); *Iron* (The Traverse and Royal Court). In the West End, theatre credits include: *Made in Bangkok, The House of Bernarda Alba, A Piece of My Mind, Journey's End, A Madhouse in Goa, Barnaby*

and the Old Boys, Irma Vep, Gasping, Map of the Heart, Tango Argentino, When She Danced, Misery, Murder is Easy, The Odd Couple, Pygmailion, Things we do for Love, Long Day's Journey into Night and *Macbeth.* For Sir Peter Hall credits include: *Lysistrata, The Master Builder, School for Wives, Mind Millie for Me, A Streetcar Named Desire, Three of a Kind* and *Amedeus* (West End and Broadway). Matt was Sound Supervisor for the Peter Hall Season (Old Vic and The Piccadilly) and designed the sound for *Waste, Cloud 9, The Seagull, The Provok'd Wife, King Lear, The Misanthrope, Major Barbara, Filumena* and *Kafka's Dick.* Work for the RSC includes: *Family Reunion, Henry V, The Duchess of Malfi, Hamlet, The Lieutenant of Inishmore, Julius Caesar* and *Midsummer Night's Dream.*

Will Mortimer
Assistant Director

Directing includes; *Opportunism, Duplicity, Paranoia* (Candid Arts Centre); *Little Deaths* (Latitude Festival); *Astronaut Wives Club* (Rehearsed Reading, Old Vic New Voices Award Shortlist); *And Baby Makes Seven* (Lion and Unicorn). As Assistant Director; *Petronella, This One's For You Hula Girl* (Old Vic Theatre 24 Hour Plays), *Cigarettes and Chocolate and Hang-Up* (King's Head Theatre).

● soho theatre

- **Produces new work**
- **Discovers and nurtures new writers**
- **Targets and develops new audiences**

Soho Theatre creates and enables daring and original new work that challenges the status quo by igniting the imaginations of writers, artists and audiences. We initiate new conversations with London and the wider world through projects that celebrate creative participation, internationalism and freedom of expression. We nurture a socially and culturally broad audience's for theatre and create a buzz around theatre as a living and relevant art form.

'a foundry for new talent... one of the country's leading producers of new writing' (Evening Standard)

Soho Theatre has a unique Writers' Centre which offers an invaluable resource to emerging theatre writers. The nation's only unsolicited script-reading service, we report for free on over 2,000 plays per year. Through the Verity Bargate Award, the Writers' Attachment Programme, and a host of development programmes and workshops we aim to develop groundbreaking writers and artists to broaden the definition of new theatre writing. Our learning and participation programme Soho Connect includes the innovative Under 11's scheme, the Young Writers' Group (18-25s), Script Slam and an annual site-specific theatre piece with the local community.

Alongside our theatre productions, Soho Theatre presents a high profile late night programme with a mixture of groundbreaking comedy and performance from leading and emergent artists. We also curate talks and other events, encouraging the conversation to spill over into our new and reasonably priced Soho Theatre Bar. Contemporary, comfortable, air-conditioned and accessible, Soho Theatre is busy from early morning to late at night.

'London's coolest theatre by a mile' (Midweek)

● soho theatre

21 Dean St
London W1D 3NE
Admin: 020 7287 5060
Box Office: 0870 429 6883
www.sohotheatre.com

Soho Theatre Bar
The new Soho Theatre Bar is a comfortable and affordable place to meet in central London.

The Terrace Bar
The Terrace Bar on the second floor serves a range of soft and alcoholic drinks.

Email information list
For regular programme updates and offers visit www.sohotheatre.com

Hiring the theatre
Soho Theatre has a range of rooms and space for hire. Please contact the theatre on 020 7287 5060 or go to www.sohotheatre.com for further details.

THE SOHO THEATRE DEVELOPMENT CAMPAIGN

Soho Theatre receives core funding from Arts Council England, London. In order to provide as diverse a programme as possible and expand our audience development and outreach work, we rely upon additional support from trusts, foundations, individuals and businesses.

All of our major sponsors share a common commitment to developing new areas of activity and encouraging creative partnerships between business and the arts.

We are immensely grateful for the invaluable support from our sponsors and donors and wish to thank them for their continued commitment.
Soho Theatre has a Friends Scheme in support of its education programme and work developing new writers and reaching new audiences. To find out how to become a Friend of Soho Theatre, contact the development department on 020 7478 0109, email development@sohotheatre.com or visit www.sohotheatre.com.

Sponsors: Angels The Costumiers, Arts & Business, Bloomberg, International Asset Management, Rathbones, TEQUILA\ London

Major Supporters and Education Patrons: Tony and Rita Gallagher • Nigel Gee • Paul Hamlyn Foundation • Roger Jospé • Jack and Linda Keenan • John Lyon's Charity • The Pemberton Foundation • The Foundation for Sport and the Arts • Carolyn Ward • The Harold Hyam Wingate Foundation • The City Bridge Trust

Soho Business Members: Goodman Derrick • ilovesoho.com

Trusts and Foundations: Anonymous • The Andor Charitable Trust • The Sydney & Elizabeth Corob Charity • The Earmark Trust • Hyde Park Place Estate Charity • The Mackintosh Foundation • The Rose Foundation • Leopold de Rothschild Charitable Trust • The Royal Victoria Hall Foundation • Saddlers' Company • Teale Charitable Trust • Bruce Wake Charitable Trust • The Kobler Trust • The Carr-Gregory Trust

Dear Friends: Anonymous • Jill and Michael Barrington • David Day • John Drummond • Daniel Friel • Madeleine Hamel • Steve Hill • Michael and Mimi Naughton • Hannah Pierce • Nicola Stanhope • Diana Toeman

Good Friends and Friends: Thank you also to the many Soho Friends we are unable to list here. For a full list of our patrons, please visit www.sohotheatre.com

Registered Charity: 267234

Hassan Abdulrazzak

BAGHDAD WEDDING

OBERON BOOKS
LONDON

First published in 2007 by Oberon Books Ltd
521 Caledonian Road, London N7 9RH
Tel: 020 7607 3637 / Fax: 020 7607 3629
email: info@oberonbooks.com
www.oberonbooks.com

A catalogue record for this book is available from the British Library.

Cover photograph by Bryon Fear

ISBN: 1 84002 783 5 / 978-1-84002-783-9

Printed in Great Britain by Antony Rowe Ltd, Chippenham.

For my parents

Saad Abdulrazzak Hussain and Munira Kamil Albayaty

Acknowledgements

I owe a great debt to Andrew Steggall, Lisa Goldman and Nina Steiger. Andrew's criticism of the first draft helped to set me on the right path. He directed a workshop week at the Old Vic theatre (October 2006) that allowed for a deep exploration of the text. Lisa and Nina's comments on subsequent drafts were always insightful and inspiring. Rehearsal of the play at the Soho Theatre (May / June 2007) under the direction of Lisa Goldman resulted in significant refinements.

I am indebted to my friend Akbar Kurtha for championing the play since its early days and fervently wanting to produce it. I am also very grateful to Mark Godfrey and all the Soho Theatre staff as well as our wonderful cast of actors.

Thanks also go to:

Cecilia Guevara Juárez, Asil Albayaty, Maysoon Pachachi, Raad Rawi, Sasha Behar, Philip Battley, Philip Arditti, Colin Stinton, Kourosh Asad, Hemi Yeroham, Will Hammond, George Kotzamanis, Annika Alexopoulou, Makram Essafi, Nadia Hamdan, Lama Madina, Saadi Omar, Zeid Albayaty, Noora Al-Huda, Farah Albayaty, Abbas Aref, Sarah Aref, Mohamed Aref, Bashar Jalal, Mahmoud Albayaty and Nouri Hussain.

Characters

SALIM

Novelist and medical doctor. Extrovert, daring, irresponsible and good looking. Writer of a controversial novel. Comes from a wealthy family.

MARWAN

Our narrator.

LUMA

Bright, beautiful and unconventional in her youth.

KATHUM

Middle aged; a rising journalist in the post-Saddam era.

YASSER

An arts critic.

OMAR

Works with his father in a food store.

IBRAHEEM

An Iraqi insurgent leader, turned to religion during the sanction years.

NADIR and SAYEF

Iraqi insurgents.

MARK BOOTHE

American Lieutenant Colonel, stationed in Baghdad. Would rather be back home.

MELISSA

Early twenties, rich American, had an on-and-off affair with Salim.

SIMON

One of Salim's lovers and his one-time muse perhaps.

and

American soldiers, Iraqi man, party guests, boy/waiter serving coffee, protesters

Notes

Scene numbers should be thought of as helpful bookmarks but granted no higher status. The majority of scenes are designed to flow swiftly one after the other. Theatre assistants could interact with the actors, handing them various props and helping to maintain the fluidity of the scene changes. If performed by non-Iraqi actors then light Iraqi accents could be used.

Act One

SCENE 1

Darkness.

The song 'Baghdad' by Ilham Al Madfai starts. In the background, images of Baghdad are projected, which chart the changes that the city has undergone. The words 'Baghdad, November 2004' appear.

A room with a mirror, a tie rack, a table with books, papers, laptop, beer bottles, vodka bottles, orange juice and other clutter.

SALIM enters followed by MARWAN.

MARWAN: Are you listening? Are you listening to me?

SALIM is hung over.

Are you listening to me Salim? I have something serious to say. Pay attention. (*Pause.*) It's your wedding day. This is a big deal; you do know that, don't you?

OMAR enters. He wants to see if SALIM is ready. His eyes meet MARWAN's. MARWAN indicates for OMAR to wait outside using the appropriate hand gesture: all the fingers of one hand closing to form a tripod and moving the hand up and down. OMAR exits.

I've been trying to be alone with you to say what I want to say. Salim, are you listening?

SALIM picks up a beer bottle.

SALIM: Is it about my drinking?

MARWAN: No, it is not about that.

SALIM: Alright then.

SALIM is searching for something on the table. He knocks a few plastic cups out of the way.

MARWAN: Today you are getting married. You are getting married to a lovely girl. Really, Zina is just…just lovely and so…so –

SALIM: Have you seen her?

MARWAN: Zina? She must be on her way.

SALIM: No I meant the opener.

He makes bottle opening gestures.

MARWAN searches for the bottle opener. He finds it and hands it to SALIM.

MARWAN: There.

SALIM: Shukran ya ma'lem. [Thank you boss*]

He blows him a kiss then opens the beer bottle and starts to drink.

MARWAN: Listen Salim. I don't know how to say this so I'll just come out and say it. Tonight may not mean much to you…in sexual terms…but for Zina, this is going to be the most important night of her adult life. She has probably fantasised about this for such a long time. It's only natural. For her, this is the start of her sex life. (*Pause.*) So I can't emphasise this enough Salim, I really can't. Whatever you do tonight…whatever you do…you must not…under any circumstances…

SALIM is now paying full attention.

Try to fuck her up the arse.

SALIM bursts into laughter, perhaps spitting some of the beer out.

SALIM: You son of a dog!

MARWAN: I really can't emphasise that enough.

SALIM: You're a real son of a dog. Fuck her up the arse! I mean hell…who'd bring that up…except you? All the guys are thinking it, I bet.

MARWAN: Don't worry. No one is taking bets.

SALIM: It's very considerate of you all to be worried about my wife's arsehole.

* This is not an Iraqi phrase but an Egyptian one. Egypt is the main exporter of films and entertainment to the rest of the Arabic world.

MARWAN: Has she read –

SALIM: Marwan, Marwan. You really think…? I mean not after today. Come on!

MARWAN: Can a leopard change his spots?

SALIM: He could always connect the dots and pretend to be a zebra.

KATHUM enters.

KATHUM: Hurry up. Why haven't you changed?

SALIM: I have.

KATHUM: You look like you're going to a bloody funeral with that tie. Don't you have anything lighter?

SALIM: I think I look fantastic.

MARWAN: Kathum is right. It's too dark.

KATHUM: See. What did I tell you? You never listen.

SALIM: Fine…fine, let's try another one.

KATHUM searches for another tie. Finds a tie with a lighter tone. They all stand in silence as KATHUM takes off the old tie and puts the new one around SALIM's neck. KATHUM begins to chuckle.

What's the matter?

KATHUM: Nothing. That scene from your book just popped into my head.

SALIM: Which scene?

KATHUM: You know when the friend character walks in on those two guys. What's the line? 'Rebecca is not here mate.' Brilliant!

SALIM: Yeah…well, I don't think it's all that funny anymore.

MARWAN: Why is that?

SALIM: Time to move on, I think.

KATHUM: You've been thinking about what we discussed?

MARWAN: What did you discuss?

KATHUM: How Salim should start tackling Iraq, the war, this whole mess.

SALIM: When I try to write about Iraq, about my first trip back in 2003 –

MARWAN: That was crazy. (*To KATHUM.*) He just disappeared!

SALIM: I had to be here. I wanted to see it for myself. This new chapter unfolding.

MARWAN: I still remember that long email you sent. 'Breathing the intoxicating –'

SALIM: ' – oxygen of freedom', yes don't remind me.

KATHUM helps SALIM to put on the jacket of his suit.

KATHUM: Oxygeen al-horriya!

SALIM: (*To MARWAN.*) See, I wasn't the only one who used it. (*Pause.*) When I try to write, it's a constant struggle to pin down what I think about all that has happened.

KATHUM: That's true even for me and I know Iraq inside out.

SALIM: (*Miming a swordfight against his reflection in the mirror.*) I am like Martin Amis swashbuckling with cliché.

KATHUM: It's early days for you. You are lucky. Novelists are allowed to ruminate. Journalists on the other hand are expected to churn, churn, churn. (*Pause.*) You need time to know the country.

SALIM: That's not going to happen. Zina is already dreaming about Harrods.

KATHUM: Shame. (*Looking at his watch.*) Time to make a move.

SALIM remembers his beer bottle. The only way to beat a hangover is to carry on drinking. Someone told him that once.

MARWAN takes SALIM aside.

KATHUM exits.

MARWAN: Salim, I know I've said this to you before.

SALIM: Marwan.

MARWAN: It's not too late to change your mind.

SALIM: We've been through all this.

MARWAN: Habbaniya is dangerous.

SALIM: Come on! Where is your spirit of adventure? Habbaniya is barely an hour's drive. We could run around there like children again. Maybe climb few palm trees!

SALIM exits.

SCENE 2

The wedding caravan.

The monologue could be animated with images, maps, video footage or through the use of the actors behind a silhouette miming the action narrated. The sound of celebratory ululations, motorcade, dancing, shots being fired, the approaching Apache and explosion could also be used.

MARWAN: (*To the audience.*) Ask any Iraqi of our generation about Habbaniya and out will flow a stream of memories. It was the place where the middle class Baghdadis went for picnics and family outings. Salim wanted the wedding there, in that place, so strongly associated with happy childhood memories.

So there we were making our way to Habbaniya. Kathum and I were near the front of the motorcade. Zina and her family were several cars behind in a white Mercedes decorated with ribbons and balloons. At the rear were Salim and his cousins on a pickup truck, dancing, singing, drinking and firing shots in the air. (*Pause.*) A wedding is not a wedding in Iraq unless shots are fired. It's like in England where a wedding is not a wedding unless someone pukes or tries to fuck one of the bridesmaids. That's just the way it goes.

A change of mood.

Then, I could see it.

Like a giant bug coming up from the horizon…this American Apache.

It dropped and headed our way. I thought it would fly a couple of times over us then bugger off. Not a chance. I remember finding it hard to breathe when I saw the flare of the missile being fired. I ducked, which is pathetic if you think about it. The missile whizzed over my car and exploded somewhere behind us.

Explosion.

It was as if a rhinoceros headbutted the motorcade and sent it reeling forward. I couldn't control the wheel. The car skidded this way and that. I veered off the road and landed in a ditch. When I looked behind…

SCENE 3

Funeral.

Verses from the Qur'an are playing. KATHUM, OMAR and MARWAN are sitting on wooden chairs. Arabic coffee is served. KATHUM and OMAR accept the coffee. MARWAN doesn't.

KATHUM: God have mercy on his soul…and on Zina's soul also.

OMAR: And why?

KATHUM: God have mercy on us all.

OMAR: Why him? Allah forgive me but why him?

KATHUM: It is His will.

YASSER enters. Sits down.

YASSER: Al-fat-ha.

YASSER recites al-fat-ha, the first sora (chapter) of the Qur'an. Al-fat-ha is read either silently or in a very low tone of voice. KATHUM and OMAR follow suit. When they finish reciting the verse, they perform a miming gesture to indicate the washing of

*their face. YASSER performs gestures of greeting towards some of
the other mourners present – for example, placing the palm of
his hand on his chest.*

YASSER: The food looks good, huh?

OMAR: Yes. Particularly the Kabab [minced beef; usually
grilled using metal skewers].

YASSER: You're right; it smells delicious.

OMAR: You can't get Kabab like that anywhere now.

KATHUM: For my money Omar, Salim's aunt is the best Kabab
cook in all of Baghdad.

YASSER: The Kabab we had at last month's funeral was also
good. Excellent, I'd say. What was that kid's name?

KATHUM: Hamza!

YASSER: The funerals are just a blur now. I am going to
develop piles from sitting on these uncomfortable chairs.

MARWAN: You are free to leave.

YASSER: No. No. I was just saying. How can I not be here? I
know he was your best friend but he was a friend to all of
us.

MARWAN: If he was here, I know what he would say.

KATHUM: Easy Marwan.

MARWAN: He would say, fuck you Yasser, you son of a bitch,
you are only here for the food.

KATHUM: Marwan.

MARWAN: You stab me in the back in your shitty column then
eat the food at my funeral.

KATHUM: Easy, easy.

YASSER: No let him get it out of his system. I could tell he was
itching to have a go at me. Is it so bad for me to do my
job? I am a critic. That's what we critics do. We criticise.

Should I make exceptions for my friends? If I made exceptions for Salim –

MARWAN: There was no need for the filthy hints you dropped about him. You betrayed his friendship.

YASSER: I am filthy? Did you read the novel? Did you? It is all about buggery. One giant fantasy about buggery –

KATHUM has noticed a new group of mourners who have entered and started another round of al-fat-ha reading. He begins to read al-fat-ha, causing OMAR and YASSER to follow suit.

– and you call me filthy? Fuck you Marwan. I was just doing my job and you know it. And to think he wanted to bring out a second volume! As if shaming his family with the first wasn't enough.

MARWAN launches from his chair like a rocket and makes for YASSER. OMAR restrains him. YASSER gets up then backs off.

MARWAN: Get out. Get out. Get out you fucking filthy ba'athi* dog. If I get my hands on you…I swear you'll be dead meat. Understand?

KATHUM: Marwan calm down. That is no way to behave.

OMAR: Guys, this is so disrespectful. We are at a funeral. It is ridiculous to carry on like this. Astekhfer Allah. [Begging the forgiveness of God.]

KATHUM: Omar is right. We are here to honour Salim's memory not to bring dishonour to his family.

YASSER: I will pay my respects to Abo Salim [the father of Salim]. (*Pause.*) I was just doing my job.

YASSER exits.

OMAR: I could have him kidnapped if you want Marwan.

KATHUM: What are you talking about Omar? Since when do you have such connections?

OMAR: I know people.

* Member of the Ba'ath party, which Saddam Hussain presided over.

KATHUM: Omar, the only mildly threatening person you know is Karam, the shoe merchant, who sells hand guns on the side.

OMAR: I know people.

KATHUM: You know people?

OMAR: Well... I know people who know people.

KATHUM: Why don't you sit down Omar and finish your coffee.

KATHUM and OMAR exit.

SCENE 4

MARWAN: (*To the audience.*) And here is the thing...we didn't meet in Baghdad. Both of our families left Iraq around the same time...just after the first Gulf War. The first time I met Salim was at the Imperial College library on the main campus.

SALIM enters reading a book.

I was studying civil engineering; he was halfway through his medical degree. (*Pause.*) He saw me eyeing the cover of his book.

SALIM: Sexuality and Eroticism Among Males in Moslem Society.

MARWAN: Oh. I guess that was a clue.

SALIM: You're no good at picking up clues.

MARWAN: Then without looking up from the page he asked me in plain Iraqi:

SALIM: Inta min Baghdad? [You are from Baghdad?]

MARWAN: One look and he knew. It was as if he smelled Baghdad in my clothes or saw the Tigris in the parting of my hair. (*Pause.*) We became friends and he introduced me to various Iraqi poets, older generation; journalists and

27

playwrights. (*Pause.*) Though he was a medic, I could tell that literature was his real passion. I began to call him –

SALIM: Keats.

MARWAN: On account of him being a literary man trapped in the body of a doctor.

SALIM: Yea, I wasn't sure about that. I'm more the Shelley type with perhaps a touch of Byron. (*Pause.*) I'll have to think of a name for you.

MARWAN: What he chose stuck.

SALIM: Marwa!

MARWAN: The female version of my name.

SCENE 5

London, 1998. Party.

MELISSA, SIMON, LUMA and the other party guests enter.

SALIM: Marwa, you're finally here! Thanks, you shouldn't have.

MARWAN hands him a wrapped bottle of wine. SALIM unwraps it; looks at the label then half turns.

Simon, catch.

He throws it to SIMON who was chatting to one of the party guests before turning around to catch the bottle. SIMON could also be offstage and never actually seen in the play.

It's another Merlot, put it at the back of the table.

SIMON nods and exits.

Let me introduce you. This is Melissa.

MARWAN: Hi.

MELISSA: Hi.

LUMA: (*To MARWAN.*) Is it true? Are you from the Albayaty family?

SALIM: And this is Luma.

MARWAN: It's true.

SALIM: Melissa's father sells yachts to wealthy Californians. He owns two fabulous villas in Phuket, right on the beach. Side by side. It's like nothing you've ever seen.

LUMA: My family knows yours very well.

SALIM: You are being rude. You can get it on later.

LUMA: (*To MARWAN.*) I am getting a drink. Would you like something Marwan?

MARWAN: A beer would be great.

LUMA exits.

SALIM: Melissa is studying medicine because she wants to help the people of the Third World.

MARWAN: That's very noble.

MELISSA: He is so full of shit. I'm studying law at Berkeley. He teases me about it all the time. It's getting old.

SALIM: I met her at a Chomsky seminar about Iraq in Berkeley last summer. I thought she was a left-wing, radical-wannabe.

MELISSA: I was dating this artist at the time. He wanted me to go with him. I'd never heard of that Chomsky guy before. No surprise; who the hell would put him on TV?

MARWAN: What? You mean you found him dull?

MELISSA: Dull doesn't even cover it. The man just mumbled on for hours…in that droning, self-righteous voice. I just totally zoned out after like ten minutes.

SALIM: I noticed how utterly gorgeous Melissa looked…and also how utterly bored so I scribbled something on the seminar flyer, turned it into a paper plane (*Mimes throwing a paper plane through the air.*)

MELISSA: That was so funny! It flew all around before landing in my ex's dreadlocks.

SALIM: Even Chomsky noticed it.

MELISSA: It was the only time he paused. (*Pause.*) All the people there were posers, I reckon. Deep down they love money as much as any normal person.

MARWAN: Well…you know…loving money is not as bad as say…loving power.

MELISSA: What's wrong with having power. You Iraqis are so idealistic. Idealistic and hypocritical.

SALIM: Ideal what? I can't even spell it.

MELISSA: Not you, sweetie. I was talking about your friends. I remember having a long conversation with your other friend at Simon's party last week. The tall guy with the Lakers' jersey. What's his name?

SALIM: Abbas.

MELISSA: He went on and on explaining how Islam respects women then just before I left, he tried to shove his tongue in my mouth. What a hypocrite.

SALIM: He was just being friendly. And who says that shoving your tongue into someone's mouth is disrespectful?

MELISSA: Not like that.

SALIM grabs her and they kiss.

MARWAN: OK, I think you guys should be left –

MELISSA: I wish you hadn't done that.

SALIM: Do you feel disrespected?

MELISSA: Yea when you do it like that in front of your friend.

SALIM: But Marwan is one of us, aren't you Marwa? Listen, we're going to the balcony upstairs. Get your beer and join us.

SALIM and MELISSA exit.

SCENE 6

Same. MARWAN sits down. LUMA comes back with a beer and a glass holding some dark liquid, she also has a spliff kit. She sits next to him.

LUMA: Do you mind?

MARWAN: No, not at all.

She starts rolling a spliff.

LUMA: I had to look everywhere for this. I think Simon has been helping himself to it. Do you smoke?

MARWAN: No, I've never tried it.

LUMA: What are you doing here?

MARWAN: I don't even like regular cigarettes. Salim invited me.

LUMA: No silly, I meant in London? What are you doing in London?

MARWAN: Oh, studying. What else?

LUMA: I know that. It's not like I had you down as the shawirma*-twirling type. What are you studying?

MARWAN: Engineering.

LUMA: I swear our parents are so lacking in imagination. All the Iraqis I know are either engineers or doctors.

MARWAN laughs.

Honestly, I was at this Iraqi communist party do last week and was being introduced around. Ahmed, engineer. Hazim, doctor, Newal, doctor, Manal, architect, Basim, engineer…etc…etc…etc.

MARWAN: So what do you study then?

LUMA: Medicine. But I'd like to be a belly dancer.

* Strips of meat or marinated chicken on a rotating skewer. The Arabic equivalent of the Turkish döner kebab.

MARWAN: Really?

LUMA: Right after I become an astronaut. Hello! I'm middle class just like you. Do you think they'll let me do something creative? (*Pause.*) What is your sister doing, you have a sister right? I seem to recall.

MARWAN: Yes I do. She is studying media.

LUMA: How awful when studying media sounds like a rebellious thing to do.

MARWAN: She didn't get the grades for medical school.

LUMA: Oh.

Silence.

MARWAN takes several swigs of his beer. LUMA sips her drink and carries on smoking.

What do you miss most about Baghdad?

MARWAN: I don't know. Nothing specific. (*Pause.*) I miss it in Ramadan. There was always a buzz and I liked the feeling of expectation as you wait to break the fast with the family. The night seemed to take on a kind of –

LUMA: I miss the night sky.

MARWAN: Yes the sky, I know what you mean, in the summer we would –

LUMA: Sleep on the rooftop.

MARWAN nods with surprise. He has never shared this memory with anyone else.

I remember it with my whole body. You climb the stairs to the roof and the first thing that would hit you, straight in the retina, is the sight of the beds.

MARWAN: All white.

LUMA: A shimmering white, it was like…like…

MARWAN: As if the moon had dropped from the sky and split into bed-shaped fragments.

Pause.

LUMA: I was going to compare them to light boxes…but I like what you said more.

MARWAN: Or to be more accurate, it was as if the moon had given birth to three or four children and was watching over them.

LUMA: Right. (*Pause.*) As I was saying, I would get into bed, the sheets would be cold and it felt so good. I always shivered for a good five minutes. Then I'd look up and see them.

MARWAN: The bats?

LUMA: We didn't get that many bats in Mansur. Did you get them in Karada?* That's where your family lived, right?

MARWAN: Yes; Karada, that's right. We had plenty of bats there, they would whiz really fas–

LUMA: We didn't get bats. I was talking about the stars.

MARWAN: The stars, yes of course.

LUMA: I wish I could see that sky again. I am not misremembering, right? It was like no other sky. Tell me it's not just my imagination going into hyper-drive.

MARWAN: It's not. You are absolutely right. The sky looked as if God had personally lit a million brilliant candles. There is no sky like it. Certainly not here in London. You would be lucky to even see –

LUMA: I always dreamt of UFOs when I was a child.

MARWAN: Me too! That's amazing.

LUMA: Not really. Many of my friends from Baghdad had those dreams. Do you still dream of UFOs?

MARWAN: Sadly no. I only dream of turning up to the exams unprepared and naked.

Pause.

* Mansur and Karada are districts in Baghdad.

LUMA: What do you think Salim and Melissa are getting up to?

MARWAN: Would you like us to join them?

LUMA: No. Why don't you help me finish this? (*She lifts up the spliff.*)

MARWAN: I don't…

LUMA: Come on. Don't be scared. Salim has them all the time and he is alright, isn't he?

MARWAN: I am not Salim.

LUMA: Its effects are much exaggerated. It will just help you chill.

MARWAN: You think I am too wound up?

LUMA: A little. Go on.

MARWAN takes a drag. He coughs.

Just take it in like you are breathing. Don't pull a Bill Clinton. Just take it in.

MARWAN: Like this?

He takes a long drag. No coughing this time.

LUMA: There you go.

MARWAN: That's not bad. It feels nice…like you are driving along and suddenly you go over a road bump.

LUMA: And your heart catches.

MARWAN: And your heart…catches.

They look at each other in silence.

LUMA: Are you OK?

MARWAN: My head is spinning but I think I am fine.

LUMA finishes the drink in her hand.

LUMA: Good. I'd hate to do some irreparable damage to you. (*She lifts the empty glass.*) Shall I get you one?

MARWAN: Sure, what the hell.

LUMA exits.

MARWAN searches for an ashtray. Finds one. Snubs out the remainder of the spliff. He takes a big breath in.

(*To himself.*) Don't vomit. Whatever you do, do…not… vomit. Especially not on her.

LUMA enters. She is holding two glasses.

LUMA: There you go. (*Hands one of the drinks to MARWAN.*) Do you want to share the next one?

MARWAN: Maybe in a little while.

LUMA sits down beside him. She rolls a new spliff.

LUMA: When Salim told me about you this evening, he said you are the only Iraqi of our age worth knowing in London…other than me of course.

MARWAN: He said that?

LUMA: He says a lot of things. I don't always take them seriously.

MARWAN: He does like to make grand statements.

LUMA: You don't have to be polite. You can say it. He likes to bullshit.

MARWAN: True. But he has a good heart.

LUMA: The only good heart a man can have is the one he rips from a woman.

MARWAN: That's a bit harsh.

LUMA: It's true isn't it?

MARWAN: Not all men are –

LUMA: Not all men are like that. That's what you were going to say, right? Why does every man always say the exact same thing? And always in that tone…like hey baby, you've just met the exception.

MARWAN: Would you let me finish?

LUMA: Did I cut you off?

MARWAN: You keep amputating my sentences.

LUMA: Sorry.

MARWAN: You must be top of your anatomy class.

LUMA: I'll be quiet. Go on. What were you saying?

MARWAN: I wanted to say that not all men are utter bastards.

LUMA: See that's honest. I like that. My theory about men is this…do you want to hear it?

MARWAN: Shoot.

LUMA: Men fall into three categories. They are either: bastards, gay or both.

MARWAN: I'm almost afraid to ask.

LUMA: I don't think you're gay.

MARWAN: Thank God it means I have hope.

LUMA: Hope? Hope for what?

MARWAN is embarrassed.

Sorry. Yes, hope. Hope is a good thing.

MARWAN: (*Changing the subject.*) Men being bastards; doesn't that depend on the country though? Do you think men back home are bastards?

LUMA: It doesn't matter.

MARWAN: I think it does. When I arrived in England, I was really very simple…very naive. After a couple of years here, my eyes opened. I changed completely. You might say I had to mature quickly.

LUMA: You mean you got laid.

MARWAN laughs.

MARWAN: I don't think I met an Iraqi girl quite like you before.

LUMA: You just haven't met all that many.

MARWAN: Oh I have, believe me. And they fall into two categories.

LUMA: Is that right?

MARWAN: Do you want to hear my categories or not?

LUMA: All ears.

MARWAN: They're either dull or excruciatingly dull. Most of the time, I just think what are they on about? And that's the dull ones. The excruciatingly dull ones don't say anything. They just sit there with their big hair and loud makeup saying nothing.

LUMA: I have a good mind to slap you.

MARWAN: I guess I'm just another one of your bastards.

LUMA: A bastard would never admit to being a bastard. It's part of the whole bastard package; everyone knows that.

MARWAN: What if I was being truthful…as an act…designed to impress you with my exemplary honesty, just to get you to like me?

Silence.

LUMA: I'd say…I'd say you don't need to try that hard.

MARWAN: (*To the audience.*) We continued drinking and talking. At one point we even started dancing. I wanted to kiss her so badly but something in her body language suggested I shouldn't. I can't remember when she left.

LUMA exits.

I got more and more drunk and high afterwards. I don't remember anything else from the party except, somehow finding myself upstairs, much later, and opening a door.

Two bodies covered by a sheet can be seen. SALIM emerges from underneath the sheet. The second person is performing fellatio on him.

MARWAN reaches for the door handle, he turns it, the door creaks. He walks in and fumbles for the light switch. The lights come on.

Salim? Oh God!

SALIM: It's cool.

MARWAN: I'm so sorry.

SALIM: It's cool Marwan. Why don't you go back downstairs. I'll be down in a while.

MARWAN: So sorry, really. Sorry Salim. Sorry Melissa.

SIMON: (*His head and upper torso emerging from underneath the covers or saying this from under the cover.*) Melissa's not here mate.

MARWAN slams the door shut. SIMON (and possibly SALIM) exit(s).

SCENE 7

Imperial College in MARWAN's recollection.

MARWAN walks slowly towards a wooden bench.

MARWAN: My head. God.

He reaches the bench and sits down.

Maybe the prophet was right. Muslims shouldn't drink. We just don't know when to stop.

SALIM is wearing his wedding suit. He is a ghost in MARWAN's memory.

SALIM: You were pretty shocked. Weren't you Marwa?

MARWAN: 'Shocked' doesn't capture it. It was like looking at a trick image that you can't decipher at first and then the image reveals itself to you.

SALIM: I remember we met next day on campus.

MARWAN gets up and hugs SALIM.

All you said was:

MARWAN: Thanks for a great party.

SALIM: But with the hug you were saying something more. You were saying I don't give a damn who you sleep with. I accept you as a brother.

MARWAN: We never talked openly about it...maybe there was no need. I filled in the missing pieces later from your novel.

SALIM: The hug was enough. It was beautiful; said everything. And anyway few days after, we fucked.

MARWAN: What?! We never did!

SALIM: I know but I am dead now...I can say whatever I like.

SCENE 8

Baghdad, December 2004.

MARWAN: (*To the audience.*) Salim wanted the invasion. (*Pause.*) Not without reservations. Not without a weighing up of pros and cons. But he wanted it all the same. (*Pause.*) He argued that Iraqis had to be pragmatic.

SALIM: Marwa, Marwa, what's so hard to understand? The Americans have changed their position. They want Saddam out and we...will you stop rolling your eyes at me...and we should be making the most out of that policy change.

MARWAN: I knew it in my bones...Salim was wrong.

The emails started within a week of his return to Baghdad. He always managed to find the few grains of hope scattered in the wasteland. Even when the photographs of the abuse at Abu Ghraib came out:

SALIM: Worse things happened at that prison under Saddam. (*Pause.*) I feel sorry for those men...but you have to admit, it has been blown out of all proportions.

MARWAN: What shocked me most about the photos wasn't the sexual humiliation of the prisoners. It was the happy expression on the faces of the torturers, who stood in front of the camera with beaming smiles and thumbs up as if they were visiting the Eiffel Tower or the Grand Canyon.

Then, out of the blue, Salim invited me to his wedding! The tornado had decided to become a gentle sea breeze. Yet somehow this decision…his decision to get married in Iraq…at this time…well it filled me with hope, it did. It was beyond rhetoric. The scale tipped and I was persuaded to return. (*Pause.*) I should have told him to get the hell out.

SALIM exits.

Image of a mosque in Baghdad – for example, the Bunia mosque. Early evening. The call to prayer is sounding. Mourners emerge from the mosque where they have been attending SALIM's arbaíenia. The funeral was held in a large room inside the mosque but separate from the main prayer hall. KATHUM and OMAR are amongst the mourners. The mourners are chatting with each other and saying their goodbyes.

We have all these rituals for death. A whole host of funerals. The first, immediately after burial then forty days later a second funeral is held known as the arba'ienia. Some families hold a third, a year later. And every year, in certain parts of Iraq, there is collective mourning for the death of Imam Husayn, the grandson of the prophet, murdered over fourteen centuries ago. We grieve repeatedly; publicly, you might even say theatrically until our grief loosens its grip and becomes mere ritual.

SCENE 9

Outside the mosque. KATHUM, OMAR and MARWAN are shaking hands with the rest of the mourners.

KATHUM: Ma' al salama.

OMAR: Ma' al salama

MARWAN: Goodbye. Ma' al salama.

The mourners exit.

Who were all these people?

KATHUM: I don't think there was a single writer, painter or poet in Baghdad I didn't shake hands with. They were all here tonight.

MARWAN: What is the point of the arba'ienia?

OMAR: Many people asked for it. Salim has become a celebrity.

KATHUM: He's become a cause. You're either with Salim's book or against it.

MARWAN: Why in a mosque? It's not what Salim would've wanted.

OMAR: I think those arty types feel safer here. No one would blow up a gathering at a mosque.

KATHUM: Don't be so sure.

OMAR: (*To MARWAN.*) We're going for some shisha.

MARWAN: I'd like to take a look around.

KATHUM: Don't stay long.

OMAR: It's dangerous after dark.

KATHUM and OMAR exit.

The call to prayer is sounding.

MARWAN: (*To the audience.*) The minaret glowed like a candle at dusk.

LUMA enters MARWAN's thoughts. The Bunia mosque meta-morphoses into the Queen's tower at Imperial College. We are in Baghdad 2004 and London 1998 simultaneously. LUMA and MARWAN are looking up at the tower.

LUMA: I can't see a thing!

MARWAN: Wait, any second now…

The tower is floodlit.

There! The Queen's tower at night! And that concludes our tour of London for today. Any tips are welc–

LUMA: It's dizzying! Why do they have a royal tower in the middle of the university?

MARWAN: It's a relic from the Empire.

LUMA: Of course…imperial College… I should've guessed. (*Pause.*) So you've brought many girls here?

MARWAN: No. No.

LUMA laughs at his earnestness.

You're the first, I swear!

SALIM enters. He is wearing his wedding suit.

MARWAN: Salim always likes to point out how the tower doesn't fit in with all the hideous Imperial College buildings… He says it stands out like…what was it?

SALIM: Like a beautiful, long phallus amongst a cohort of stubby cocks.

LUMA: Don't tell me. I don't want to know.

SALIM: You never told me you had a fling with Luma.

MARWAN: 'Fling' doesn't sound right.

SALIM: Well…did you fuck her?

MARWAN: No. We didn't make love…but that wasn't the point. We spent –

LUMA: Five weeks.

MARWAN: Five weeks…like new arrivals. Walking for hours through the city.

LUMA: There was so much of London that I hadn't seen. I always meant to get around to it but somehow it never happened.

SALIM: Too busy having fun. Did you kiss her at least?

MARWAN shakes his head.

MARWAN: I should have kissed her that night. In front of the tower. In the dark. It was –

LUMA: The perfect moment.

SALIM: And you blew it.

MARWAN: I thought we'd have all the time in the world.

Suddenly daytime. It's another memory. A small group of protesters rush in, handing out leaflets and flyers. Some of the flyers fall on the ground.

What's going on?

SALIM: It's a demonstration.

MARWAN: That's right, you were there. I was surprised to see you.

SALIM picks up one of the leaflets from the ground.

SALIM: (*Reading a leaflet.*) 'We are against the planned attack on Iraq. We are against a president using war to distract the public from his scandals. We are against – ' (*Stops reading.*) You know all throughout that time, I couldn't bring myself to really hate Clinton.

MARWAN: I hated your ambivalence. How could you forgive him?

SALIM: Charm buys forgiveness.

LUMA: Only for so long.

MARWAN: (*To LUMA.*) You didn't speak to each other that day.

SALIM: He was human at least.

MARWAN: (*To SALIM.*) You didn't speak –

LUMA: He was like any other randy man. Don't make excuses.

SALIM: The hunger for a decent blowjob can be a powerful thing.

LUMA: Do you think you sound clever when you say things like that?

SALIM: No, just truthful.

LUMA: You'd blow up a country for a blowjob?

SALIM: I'd forgotten that about you…that special way you have of using repetition.

LUMA: What else did you forget?

SALIM: Not much.

Protesters enter. SALIM is pushed out of the way by them and at some point exits during the ensuing action. The protesters are carrying banners and placards and shouting anti-war slogans. The banners and placards should make it clear that this is taking place during the Clinton regime. Some could be humorous – for example, 'Not in my name. Not on my dress.'

MARWAN and LUMA take a placard each and join the demonstration. The multitude of slogans begin to merge into one word repeated over and over: 'Stop! Stop! Stop!'. A jet plane approaches. Bombs begin to drop on Baghdad. The sound of bombs descending or missiles fired is heard. There is expectation of a blast. Instead we hear silence. The protesters are showered with red shredded anti-war leaflets. The silence persists. The protesters throw their banners and placards to the ground. They begin to disband. One of the Iraqi girls protesting hands LUMA a letter. She reads it. A veil of sadness descends on her face.

MARWAN: What's happened?

She begins to weep.

Luma.

LUMA: I need to go home.

She runs up and hugs him then whispers a few words to him before exiting.

Silence.

MARWAN: (*To the audience.*) Misfortune carried her away. I thought I'd never hear from her again until one day, a letter arrived. It was written on scented pages, the last thing you imagine coming out of Iraq.

The call to prayer is coming to an end. MARWAN emerges out of his reverie.

MARWAN exits.

SCENE 10

Baghdad, January 2005. Café. There are election campaign posters on the wall, or relevant news footage of the days leading up to the election on 30 January could be used instead. OMAR and KATHUM are sitting opposite each other. There is a table between them. Somewhere nearby is a stack of domino and backgammon boxes. Domino pieces are spread on the table.

OMAR: So I am going to the shop and I get to our road. Fine. Same as always. But then I end up walking past the shop… just past it…why? Didn't recognise it. Sandbags stacked up to here: (*Indicates.*) You couldn't see the windows anymore. It looked like a little bunker. Abu Majed, down the road, laughed and said 'look at your dad's handy work'. I go in and there he was. My dad. Kalashinkov at the ready. Normally he keeps it under the counter.

KATHUM: Naturally.

OMAR: Yabba, what happened? Explosions, he tells me. What explosions? I mean I look around the shop, I actually look around the shop; I take him seriously.

KATHUM: Confused.

OMAR: Confused and embarrassed. Dawrah* was bombed yesterday. This is what really happened. Oh you should hear my mother tell it. So he woke up in the middle of the night. Had dreamt that some gang of men were eyeing up the shop. I mean the poor woman.

KATHUM: With her arthritis.

OMAR: Exactly and having to piece together such nonsense. She just went back to sleep after he left the house. It's not the first time he pulled a stunt like this. What is still a

* A district in Baghdad.

mystery are the sandbags. Where did he get them from? Middle of the night. Each this big: (*Exaggerating the size.*) Man pushing seventy, probably well beyond that, and putting up sandbags. Must have taken him all night.

KATHUM: With his back.

OMAR: Lucky he didn't get stabbed. I told him: Dad, Dad, hayaty [my life] …who would bomb us? We're selling cheese and olives…not hosting Iyad Allawi*. (*Indicates an election poster.*)

KATHUM: Poor man.

OMAR: So he spent all night putting up sandbags and I spent all morning taking them down. And of course, we sold nothing. (*To WAITER.*) Bless those hands. (*Takes a sip of the tea.*)

KATHUM: (*To WAITER.*) I'll have coffee. Black. Extra sugar. But not like last time.

OMAR: Another round?

OMAR picks up a domino box.

KATHUM: (*To WAITER.*) It was like drinking syrup. (*To OMAR.*) Let's make it quick.

OMAR: You have to be somewhere?

KATHUM: Do you know Luma? Doctora Luma, daughter of Laith Rawi?

OMAR: The surgeon.

KATHUM: That's right.

OMAR: God rest his soul. Awful how he died.

KATHUM: One of those dumb smart bombs, wasn't it? He was on night duty. Pity. Anyway –

OMAR: During Desert Storm.

* The interim Prime Minister of Iraq prior to Iraq's 2005 legislative elections.

KATHUM: Much later…Desert Fox.

OMAR: I don't remember that one.

OMAR tries to engage the attention of a waiter who has just served a plate of fried eggs to another customer.

KATHUM: Clinton's little diversion…when that Lewinsky woman grabbed him by the –

OMAR: (*To WAITER.*) Two – boiled! – and some bread, shoukran azizi. [thank you, my friend]. (*To KATHUM.*) You were saying?

KATHUM: I bumped into her yesterday. Doctora Luma, I mean. We got chatting and it turns out she knows Marwan.

OMAR: Marwan? Our Marwan?

KATHUM nods.

KATHUM: They were friends…Luma and Marwan…from their London days. So I offered –

OMAR: Wait…wait…isn't that the same doctora Luma who ended up marrying that rich doctor from Al-Hadithi family?

KATHUM: That's her.

OMAR: Jealous type. Beat her up.

KATHUM: I thought the problem was impotence? (*To another café customer.*) Not you Abo Sarmad…someone else, someone else.

OMAR: I heard… (*Whispering.*) see I heard the husband found all these letters she'd been getting so – (*He slaps his hand repeatedly.*)

KATHUM: You wouldn't think that happens amongst doctors.

OMAR: It happens now. And more than you think.

OMAR takes a sip of tea. KATHUM picks up a domino tile and begins to examine it.

Look at this. (*He picks up another tile.*) You can barely make out the numbers anymore.

OMAR: Like a dog's been chewing them all night.

KATHUM: I swear even the little things are falling to pieces.

OMAR: But tell me more about this impotence business. I haven't heard that one.

SCENE 11

The house of MARWAN's grandfather.

Night time. The faint sound of crickets could be heard. MARWAN emerges from the house into the garden. He is dressed in jeans and T-shirt and is carrying a full garbage bag. He places the bag outside the house. As he heads back towards the house, he hears the sound of a car pulling outside. He spots KATHUM, offstage in the car. Waves at him. The passenger door is opened, someone exits and then it is shut. MARWAN hesitates. LUMA enters. She is wearing a hyjab.

MARWAN: Luma?

LUMA: Hello Marwan.

Pause.

You've hardly changed. You look a little more gaunt.

Silence.

Lost for words?

MARWAN: Yes.

LUMA: I don't blame you, it's been five years.

MARWAN: Six. (*Pause.*) Six years and a month.

LUMA laughs.

LUMA: And days? And minutes? Come on, don't disappoint me.

MARWAN: I thought you moved to Basra.

LUMA: I came back after the divorce.

MARWAN: Your letters, they stopped.

LUMA: I know; I'm sorry. I was in no state to write.

MARWAN: How do you know Kathum?

LUMA: Come on. There aren't many people like him…like us…left here or haven't you noticed?

MARWAN: What do you mean by that? What kind of people are we?

LUMA: People who are partial to a bit of the old Johnny Walker every now and then.

MARWAN: (*Laughing lightly.*) Many things have changed…but some things are just as I remembered.

LUMA: Aren't you going to invite me in or are we spending the night here? I don't mind but maybe your neighbours will talk.

MARWAN: Thanks to the 'resistance', people are less inclined to look out of their windows.

He is about to open the front door then decides against it.

You know it might just be easier to take the back stairs. It's quicker to get to my room that way.

LUMA: That's a bit presumptuous of you Marwan.

MARWAN: It's where Mr Walker is staying.

LUMA: Really?

MARWAN: So if you hope to meet him tonight (*Registering the hyjab.*) or perhaps –

LUMA: Take me to him.

SCENE 12

MARWAN's room. It contains a desk and a bed. Books and papers are scattered everywhere. The room has functioned as storage space for many years.

The door opens. MARWAN and LUMA run through. MARWAN closes the door quickly.

LUMA: Who the hell was that?

MARWAN: My uncle. He always sleeps with the door open.

LUMA: What did he shout?

MARWAN: He was just snoring.

LUMA: God, it was barely human!

MARWAN: I know. I have to put up with it. My uncle and cousins are the last of the family left in Baghdad.

LUMA: Good to have those stairs. Handy if you ever need to exit in a hurry.

MARWAN: Why would you need to do that?

LUMA: You know…if a bomb goes off.

MARWAN: That doesn't happen around here.

LUMA: Give it time.

She takes a look around the room then looks at him.

I would have never guessed you were such a pig.

MARWAN: No one comes up here.

LUMA: Do you just stay here all day reading books?

MARWAN: They belonged to my grandfather. This is…this was his house.

LUMA: I didn't know that.

MARWAN: He built the annex at the back to store his massive book collection. Not much is left now. My uncle had to sell them over the years and rent out the annex to make ends meet.

LUMA: You had to compromise during the sanctions, if you wanted to survive. (*Pause.*) How long have you been here Marwan?

MARWAN: I came for Salim's wedding. Did you know about it?

LUMA: I knew.

MARWAN: Were you still in Basra?

LUMA: No.

MARWAN: Why didn't you –

LUMA: (*In a mock American accent.*) So where's Johnny?

MARWAN: What?

LUMA: Mr Walker.

MARWAN: Oh. Yes. Sure.

Pause.

I brought a couple of bottles with me from London thinking that alcohol would be hard to get but I guess I was wrong.

LUMA: You can get everything now, provided you can afford it.

MARWAN opens a cupboard and begins rummaging for the bottle.

MARWAN: Did Kathum tell you about the mysterious case of the missing whisky?

He finds the bottle.

LUMA: No. Sweet man, Kathum.

MARWAN: Yes, very. Stuck it out here through and through. Kept his head low. Always found a way of not joining the Ba'athis.

LUMA: What about the whisky?

MARWAN: I'm just looking for glasses. I had them somewhere.

LUMA: No, you said something about 'the mysterious case…'

MARWAN: Ah. Yes. So he tells me that when the Americans took over, they found all these cases of limited edition blue label. A room just full of them.

A bottle like that costs…I don't know…at least two hundred dollars. This is what they found in the presidential palace.

He pours some whisky.

LUMA: Our beloved green zone now.

MARWAN: That's right.

LUMA: Was it Saddam's late night tipple?

MARWAN nods.

MARWAN: They just vanished. Kathum reckons the people who were previously called the opposition are spending their evenings in their fortified compounds drinking all this great whisky. Cheers!

They tap their glasses and drink.

LUMA: Many things are mysteriously vanishing, not just whisky. Perhaps someone should be opposing the opposition?

MARWAN: That reminds me of an old cult comic book. It had the tagline 'who watches the watchmen?' So…who will oppose the opposition?

LUMA: The opposition of the opposition will oppose the opposition.

MARWAN: And fight crime and catch terrorists and give out candy to the free, democratically elected people of Iraq.

Pause.

So what's with the headscarf then?

LUMA: This thing. Oh you know. I got a letter from Al-Qa'ida saying if I renew my membership, I get the scarf for free.

MARWAN: Who could resist?

LUMA: Exactly.

MARWAN: What happened to the dope fiend that I know and…

Pause.

LUMA: Dope fiend! Never! What a scandalous allegation.

MARWAN: Well I remember you rolling a pretty expert joint.

LUMA: I have the memory of a goldfish.

MARWAN: I see you have already mastered the art of Arabic hypocrisy.

LUMA: It's an essential skill around here.

MARWAN: Luma, I thought you would be the kind of woman leading the fight against all this.

MARWAN touches her scarf. LUMA backs away.

LUMA: You've been away too long. (*Pause.*) This is a great subject to debate on a Wednesday afternoon on some beautiful London campus but here it is absurd.

MARWAN: I expected –

LUMA: What? I'd still be dressed the same way. Does that really matter?

MARWAN: It's a little shocking when someone abandons their principles so radic–

LUMA: Principles?! When you leave your house not knowing whether you'll come back in a body bag, when you work in a hospital where you have to throw out everything you learnt in London in favour of constant improvisation, when you virtually have an orgasm every time you hear the whirl of electricity turning back on and feel grateful for every lousy minute of light you get, when you have this…this… Everest of shit to deal with every day, the last thing you worry about is whether you are betraying your principles by wearing a hyjab.

MARWAN: What I meant –

LUMA: I am beginning to think God exists. I don't know how he wants me to dress but I feel him with me.

MARWAN: Must be a strange kind of God.

LUMA: No, just a bit melancholic…perhaps also a little lonely…can't be easy with all that time stretching ahead to eternity. Let's get off this subject. (*Pause.*) I wanted to ask you if you have his book…Salim's book.

MARWAN: The book…yes…sure. It's here…it's here, somewhere.

MARWAN searches for the book then remembers it is sitting on top of a box stuffed full of letters on his desk. He goes to the desk, takes the book and hands it to LUMA.

LUMA: Thanks. (*Reading the title.*) 'Masturbating Angels.' You have to hand it to him. He was always good at titles…titles and endings.

MARWAN: The Arabic publishers changed the title and put it out as 'the death of angels' or something like that.

Pause.

LUMA: It's gone out of my head.

MARWAN: What has?

LUMA: The Arabic word for masturbation.

MARWAN: I didn't know there was one.

LUMA: Of course there is! You can't have fifty words for sand and none for wanking.

She thumbs through the book.

From what I heard, I am guessing it's all about him and Simon.

MARWAN: Not entirely.

Pause.

Simon is in there, of course; that's why the book has become notorious. He hit on a good theme, I think. The Arab venturing into the 'dark heart' of white England.

LUMA: So he ripped off Conrad?

MARWAN: Well there was that one reviewer who described it as 'Heart of Darkness…but a little more gay'.

LUMA: So it *is* about him and Simon.

MARWAN: This is where it gets complicated. Salim's alter ego, when he finally falls in love, he falls for someone quite different.

LUMA: Different, how?

MARWAN: A girl.

LUMA: Ah.

Silence.

MARWAN: I was never absolutely sure about that. You never talked about it.

LUMA: You never asked.

MARWAN: I often wondered why he stopped talking about you after the party.

LUMA: The party?

MARWAN: Where you and I –

LUMA: Yes, the party! God that's like something out of another lifetime. (*Pause.*) We tried to stay friends… It didn't work out.

MARWAN: Was it you who ended it?

LUMA nods.

Because of Simon?

Pause.

LUMA: It's strange I know…and certainly no one around here would get it…but I understand that side of Salim now. He was a kid, running around, trying everything on. He needed that to write. (*Pause.*) It was the women I couldn't tolerate.

MARWAN: He is gone.

LUMA: I know. (*Pause.*) I couldn't come before now. I wanted all the mourning to be over.

MARWAN: Every time the doorbell rings, I keep thinking it will be him, swaggering in, champagne bottle in hand.

LUMA: He never rang the doorbell.

MARWAN: No. You're right. Always banged the door like a drum or barged in somehow. Straight to the fridge.

LUMA: Or the bedroom. Why didn't he have the wedding in Jordan like everyone else?

MARWAN: Because he is…because he was insane. You know how stubborn and impulsive he could be.

LUMA: And arrogant and selfish and so…so unpredictable. (*Pause.*) He had such a knack for making you feel like the most desired being on the planet. Trouble was he made a lot of people feel that way.

'Michael' by Franz Ferdinand starts playing. The music is coming from somewhere underneath. It is faint at the beginning and then gets louder.

Where is this coming from?

MARWAN: Downstairs, from Hamada's room.

LUMA: One of your cousins?

MARWAN: Yes.

Pause.

LUMA: This song has some pretty interesting lyrics.

MARWAN: I know. I always think of Salim when I hear it.

LUMA: Me too.

MARWAN: I don't think Hamada understands what's being said.

LUMA: Maybe that's a good thing.

MARWAN: He is always burning CDs and selling them to his friends at school. Sometimes I think everyone here has

turned into a hustler…even my little cousin. (*Pause.*) It tickles me a little to think of him selling this music to some of the more religious kids. Can you see it? Teenage boys – in public all macho – but alone in their bedrooms would dance to this song –

He starts doing a dabka, a traditional folk dance involving the stomping of feet, while singing some of the song's lyrics – particularly the lines 'sticky hair, sticky lips, stubble on my sticky lips' and 'Michael, you're dancing like a beautiful dance whore'. LUMA laughs and joins him. They continue to dance and sing. At some point MARWAN might pause the singing, while continuing to dance, to say something like: 'You can just see them dancing and singing along without any understanding.' The music stops suddenly. A moment of awkwardness.

More?

LUMA: No. I've had enough. Are you having some?

MARWAN: Just a little. Go on.

LUMA: I shouldn't.

MARWAN: Don't pull a George Bush. Have a drop.

LUMA laughs.

LUMA: When you put it like that.

LUMA sits down on a chair next to MARWAN's desk. MARWAN pours more whisky in their glasses. LUMA notices the box full of letters and papers. MARWAN freezes. She opens the box.

LUMA: You brought these with you from London?

MARWAN: Yes.

LUMA takes out some of the letters.

LUMA: My God, you've kept them all. You've even printed out the emails.

(*Pause.*) I couldn't keep anything of yours.

MARWAN: Because of…

LUMA: He made me tear them letter by letter. (*Pause.*) I don't know whether he was insanely jealous because he was impotent or impotent because he was insanely jealous.

SCENE 13

The café. KATHUM and OMAR are playing backgammon. There is a glass of tea in front of OMAR. KATHUM is smoking a water pipe. They are focused on the game.

OMAR: (*Looking up from the game.*) Of course, her husband could have found the letters *and* been impotent at the same time.

KATHUM: Don't start again.

OMAR: I am just saying. I mean for argument's sake. A man could be more than one thing at a time. He could have two defects like jealousy and…something else.

KATHUM: I think I know what you mean.

OMAR: You do?

KATHUM: Yes. Like for example, every night a man could lose to his friend in dominos and backgammon.

OMAR: You are not taking me seriously.

KATHUM: No, I am. A man could stink at two things simultaneously. Don't feel bad. It's very common.

OMAR: Screw you.

KATHUM: Shoukran habibi but tonight I have a headache. Now let's finish this so I can go home.

KATHUM and OMAR exit.

SCENE 14

MARWAN's room. MARWAN and LUMA are leaning against the foot of the bed – or mattress. The whisky in the bottle has substantially reduced. They have both taken off their shoes. LUMA's scarf is hanging on her shoulders. The letters and emails are scattered all around. She has a bunch of them in her hands.

LUMA: I can't believe how much I had told you.

MARWAN: It's easier to be honest on paper.

LUMA: Everything is here. I can see how I talked myself into it. Family…duty…necessity. I used that word 'necessity'. Can you believe it? It's all in here. The build up to the whole bloody disaster.

MARWAN: You have to let that go now.

LUMA: I was such a fool.

MARWAN: No, just made a wrong decision.

LUMA: Couldn't you see it coming from this?

MARWAN: I tried to warn you.

LUMA: You didn't do enough.

MARWAN: I tried.

LUMA: Your letters just confused everything.

Silence.

They look well thumbed.

Pause.

How many times did you read each one?

MARWAN: I could recite a few.

LUMA gets up. She is agitated.

LUMA: How did it all turn to shit so quickly? From dad's death to my disastrous marriage to watching Iraq being raped over and over. Then Salim has to go and get himself killed. And you, you did not help.

MARWAN: Come here.

LUMA: Is this some strange fantasy?

MARWAN goes to her and they kiss.

All this time?

MARWAN: Yes.

He kisses her again with greater intensity then removes the scarf from around her shoulders and flings it towards the bed. She reaches for his T-shirt and removes it. The light begins to dim as they continue to kiss and undress.

Darkness.

A faint light. SALIM enters. He is wearing his wedding suit but it is torn and dirty. A lit cigarette is dangling from his mouth, or he might light it on stage. He begins to dance. The dance turns into a quick spin, similar to the dance a dervish might perform. His face carries the joy of someone who has been given a second shot at life. He exits the stage dancing.

Darkness.

Act Two

SCENE 1

Baghdad, February 2005. The office of the newspaper where KATHUM and YASSER work. KATHUM is sitting behind a desk typing away on an HP laptop with Arabic keys. He is wearing reading glasses and is absorbed in his work.

YASSER enters. He is holding a piece of paper and is fuming. He paces up and down in front of KATHUM's desk. KATHUM knows what this is all about but pretends that he has to finish the most important sentence of his journalistic career. This goes on for some time. KATHUM stops writing.

YASSER: How dare they?! Who do they think they are, ganging up on me. Have you read this? Do you know what they're saying?

KATHUM: I have a feeling you're going to tell me.

YASSER: (*Shaking the piece of paper then reading it.*) 'He was a censor under Saddam and is now positioning himself to be a censor under the coming Islamic government.'

KATHUM: What do you want me to say Yasser? With democracy come petitions. Get used to it.

YASSER: I have been a critic for fifteen years. In Syria they consider me the 'most important literary critic – '

KATHUM: ' – of his generation'. I know. I know.

YASSER: They want me fired! These so called…writers.

KATHUM: And poets and painters and actors.

YASSER: And over what? A review I wrote of a mind-polluting novel.

KATHUM: At least it isn't a work of propaganda, Yasser.

YASSER: You know what Kathum, let me put this to you and you see if it is not a perfectly legitimate thing to raise. So Salim arrives –

KATHUM: Is this going to be long?

YASSER: Are you on their side?

KATHUM saves what he is writing on the computer.

KATHUM: OK, let's have it.

YASSER: So Salim arrives here at the most critical period in Iraq's history since the '58 revolution; and what does he write about? The war? The political situation? The deteriorating relationship between east and west? I mean these are juicy topics. Plenty of meat on them. Plenty. Oh no, none of that is good enough for Mr Salim. He has to go and write a fantasy about fucking some English guy.

KATHUM: I put that point to Salim once…although I worded it a little differently.

SALIM enters, carrying a bottle of Arak, a small bottle of mineral water and two glasses.

YASSER: And what did he have to say?

KATHUM: We drank Arak that evening so my memory is a bit shaky.

KATHUM leans back into his chair trying to remember. SALIM sits on the desk.

That's it! I asked him: Salim, why 'Masturbating Angels'? I mean you could write about anything you like…but you don't have to be Iraqi to have written this novel.

YASSER: Precisely!

KATHUM: That's what he said.

SALIM: That is precisely why I wrote it.

KATHUM: Explain it to me. I don't get it.

SALIM begins to prepare the Arak as he is speaking to KATHUM. He pours two shots of the drink in their respective glasses, adds mineral water, turning the drink cloudy, and hands KATHUM a glass.

SALIM: In England, they have this prize. This ridiculous prize called…The Booker. Now you can't be an Indian writer,

for example, and hope to be nominated for this fucking thing without at some point having someone describe in your novel what it is like to…say…slice a mango…or some other 'exotic' fruit…or there'll be someone running through some luscious forest or hovering on a carpet carried by invisible waves of magic realism. It's as if you have to carry India like some dead bird around your neck before you can be admitted through the gates. Fuck that.

KATHUM: What's wrong with mango?

YASSER: Eeee [yeah], what's wrong with mango? I like mango.

SALIM: If I want to write about mango or dates or oil or Islam or the war or whatever then…sure…by all means but I also reserve the right not to. (*Pause.*) I think things will change. This war will change how we are perceived.

KATHUM: I doubt it. I doubt it very much. We are insignificant and doomed to be misunderstood.

SALIM: No. This war has put Iraq on the map. People now can make connections between their corner of the world and this place in ways that were not possible before. So the degrees of separation are finally collapsing.

KATHUM: Collapsing my arse. OK, it's true that after the liberation, invasion, occupation, whatever you want to call it, yeah, it was wonderful to finally do some real journalism again and feel connected, even in a small way, to the outside world. But now what good is it doing me to have the sympathies of the Independent?

YASSER: Good you told him. We are here living it. They are there watching it. You can't get more separated than that.

SALIM: People are engaged by Iraq now and I am talking about people that don't even normally get involved in politics. Something good must come out of this.

KATHUM: So why haven't you written about Iraq? It's in your blood, you can't run away from it.

SALIM: I'm just not ready darling. (*Pause.*) You know sometimes it takes an outsider to show the native what he keeps missing. But in this case, am I the outsider or the native?

KATHUM: Both. (*Pause.*) You are both, Salim.

SALIM exits.

YASSER: 'Something good will come out of this!' Do you know what will happen the day after the Americans pull out? We'll be instantly forgotten.

Phone rings. KATHUM picks it up.

KATHUM: Ahlan… Ahlan – [hello]

YASSER: We could be tearing each other to shreds by then and no one…no one…

KATHUM: What are you saying?

YASSER: Will give a dry lump of shit about it.

KATHUM: No! How is that poss– (*Pause.*) OK, OK, I'll be right there.

KATHUM hangs up the phone. He is stunned.

Yasser, get ready to believe in miracles.

YASSER and KATHUM exit.

SCENE 2

Three days later. The rooftop of MARWAN's house. The moon and stars light up the scene. The sound of gunfire, distant and near, could be heard. MARWAN is sitting on a chair. There is a small table beside him with a pot of tea and a glass cup. He takes out a note from his pocket and reads it.

KATHUM: (*Off.*) Marwan?

MARWAN: I'm up here. (*He puts the note back in his pocket.*)

Enter KATHUM.

KATHUM: My God where have you been?

MARWAN: What is it?

KATHUM: Why haven't you been answering your phone?

MARWAN: I took a little trip to Kurdistan.

KATHUM: You did what? Kurdistan? Tell me you're just fucking with me?

MARWAN: It's not so bad, once you get to Kirkuk. What has happened?

KATHUM: Allah give me patience. Why am I cursed with mules for friends? Who the hell goes to Kurdistan at these times?

MARWAN: Kathum.

KATHUM: This is the most dangerous stretch of road in all of Iraq right now.

MARWAN: I wanted to see it. I needed to see something beautiful. (*Pause.*) It is peaceful up there. Quiet.

KATHUM: Never mind. This is not what I came for. Have you heard? Do you know what has happened?

MARWAN: Someone died?

KATHUM: No. No. In fact, I'd say the opposite has happened. Marwan, he is not dead. He came back.

MARWAN: Who?

KATHUM: Salim!

MARWAN: What are you talking about?

KATHUM: Salim is alive! He turned up three days ago. Just rang the doorbell.

MARWAN: What?

KATHUM: His mother nearly dropped dead on the doorstep. He looked like he'd been spat out of hell.

MARWAN: Take me to him. Is he at home?

KATHUM: No. They took him to hospital.

MARWAN: Why?

KATHUM: Don't worry, he's fine.

MARWAN: Kathum, why the hospital?!

KATHUM: His foot…broken. And his body…was dotted with all these strange – (*He moves his hands over his body to indicate bruises.*) – blue-ish…black…like he'd been –

MARWAN: Let's go now.

KATHUM: But to be honest, I'm more worried about his mind.

MARWAN: Now, Kathum. Now. Tell me the rest on the way.

MARWAN wants to leave.

KATHUM: Wait… Wait. We can't go just yet. (*Regarding the tea.*) Is this fresh?

MARWAN: Why not?

KATHUM sits down, opens the lid of the teapot and takes a look inside.

KATHUM: There's a police car at the end of your street.

MARWAN: So what? Come on, let's not waste time.

KATHUM tips out the remainder of the tea in MARWAN's glass and begins to pour fresh tea into the glass.

KATHUM: There is a curfew on.

MARWAN: I don't care.

KATHUM: I lied to those policemen; told them I was visiting my shell-shocked brother.

MARWAN: Let's go, come on.

KATHUM: That didn't wash so I had to bribe them.

MARWAN: We'll take our chances.

KATHUM: We'll wait a little. (*He takes a sip of tea.*) Ahhhh. Good.

MARWAN: No.

KATHUM: Ig'oud raha. [Sit down and be still.] You really have a death wish. First Kurdistan. Now you can't wait few minutes. I'm telling you, it will be easier to move around after midnight. Please sit down…sit down.

MARWAN looks unconvinced.

Look, how do you think I've survived as a journalist all this time? I just have this instinct for when to move and when to stay put. Now sit down.

MARWAN's agitated state slowly dissipates. He sits down.

Silence.

MARWAN: Did he tell you what happened, did he give you the details?

KATHUM: I haven't talked to him properly yet. On the first day he mostly slept and yesterday it was too crazy. Family and neighbours dropped in with food and sweets; kids running around the bed, his aunties bursting into rounds of ululations.

MARWAN: Where has he been all this time?

KATHUM: I don't know. (*Pause.*) Yasser says…God must have sent Salim back down because he was fucking all the angels.

They laugh lightly. The laughter dies down and turns to silence.

MARWAN: If Salim is alive then who did we bury?

Pause.

KATHUM: We buried what we could find.

KATHUM and MARWAN exit.

SCENE 3

Hospital ward. It is in one of Baghdad's better hospitals but it still looks rough.

SALIM is sitting on a plastic chair, or up on a bed. He is wearing a white vest and shorts and is staring into the distance. His leg is resting on a small plastic stool. The ankle is swollen and there are dark purple patches on his leg and on his back, visible later when he gets up. A pair of crutches are leaning against a metal locker. To one side of him, there is a radio with extended antennae. On the other side is a big pile of newspapers. On his lap is an old copy of Robert Fagles' translation of The Odyssey.

OMAR is sitting on a chair a little distance away. There is a cardboard box beside his feet. He is talking on his mobile phone.

OMAR: Dad, I'm handling the situation. I am dad, I am.
(*Pause.*) No…this is different…it's nothing like the…
(*Shaking his head.*) It's not, it's not…this is nothing like the time I bought the dodgy carrots, and they were not dodgy dad. (*Pause.*) What? (*Pause.*) They didn't. Dad, they didn't. How many times – (*Pause.*) Those carrots did not glow in the dark. (*Firmly.*) I tested them. I even had Dr Khalid bring over his Geiger counter, remember? (*Pause.*) This is different. Don't compare this to the carrots situation dad, please don't. I'll take care of it. I will.

He hangs up.

(*To SALIM.*) Salim, would you like me to get you something? Some food perhaps?

SALIM shakes his head. KATHUM enters. OMAR brightens up.

KATHUM: Allah bel khair*. [Good evening.]

OMAR: Kathum. Shlonek! [How are you!]

SALIM: Kathum, good to see you. Take a seat. Omar could you please fetch another one?

OMAR picks up the box.

* Idiomatic Iraqi greeting which shortens the longer phrase 'Massa' kum Allah Bilkhair', meaning 'good evening'. It is exchanged among men in the first few minutes of a conversation to break the ice.

OMAR: Actually, I'd like to step out for a while if that's alright with you Salim.

SALIM: Yes, sure.

KATHUM: Where are you going?

OMAR lifts the box slightly, as if he is shrugging. KATHUM looks at the box and remembers the story OMAR told him about it.

Oh.

As OMAR exits, MARWAN enters; they exchange greetings.

There is someone with me.

SALIM looks beyond KATHUM.

SALIM: Marwa!

SALIM gets up and begins to hobble towards MARWAN. This catches KATHUM by surprise and he scrambles for the crutches. MARWAN runs towards SALIM and catches him before he falls.

MARWAN: You're really here!

SALIM: What did you think, you son of a bitch that I died and left you all alone?

KATHUM: Sit down. Sit down.

SALIM: (*To KATHUM.*) I've been sitting down all day. (*To MARWAN.*) You should know that when I die, I'm taking you with me. Someone has to keep me company in hell.

SALIM slowly hobbles back to his chair.

MARWAN: I feel like I woke up from a horrible nightmare.

SALIM: Marwan. We are in the nightmare. Zina is dead. Half of her family are dead. My cousins are dead. (*Pause.*) Why the fuck did I not listen to you?

MARWAN: Habbaniya was once a beautiful place.

SALIM: What matters now is that it's close to Fallujah. (*Pause.*) I was so…typically…fucking…selfish.

MARWAN: Salim stop. You had no way of knowing what was going to happen. None of us did.

KATHUM: This is your country and you have the right to have your wedding wherever you please. They died…we nearly all died…because a pimpled American pilot had no clue what an Iraqi wedding looks like.

MARWAN: All the papers wrote about it.

KATHUM: We gave you a false name. For the sake of your family. Certain people would have claimed it was divine punishment.

SALIM is briefly puzzled.

SALIM: On account of the novel! Good thinking. Yeah I could see it: 'Breaking News – (*He moves his hand to indicate a headline appearing at the bottom of a TV screen.*) – God strikes down the sodomite.'

MARWAN: The story was in the news for a couple of days only. Things here move very fast.

KATHUM: Even though we're just standing still.

SALIM: (*Looking at the pile of newspapers and picking up MARWAN's point.*) I know, I feel like I've been gone for three years, not three months.

(*To MARWAN.*) Did you vote?

MARWAN: No. I needed a break from Baghdad.

KATHUM: The nutter went up to Kurdistan.

SALIM: Why? Did you want to check if they had already declared independence?

MARWAN: I just…I'd never been there before.

SALIM: Beautiful, isn't it?

MARWAN: Yes.

SALIM: Sit down; sit down. You're going to give me a headache looking at you.

MARWAN sits down. SALIM indicates to KATHUM to bring the stool closer. He puts his leg on it.

Look at my poor foot.

KATHUM: They removed the cast.

SALIM: Finally!

KATHUM: They were waiting for a new batch of X-ray films; that's what I was told yesterday.

SALIM: I don't know how the doctors here are managing. They lack the most basic provisions.

KATHUM: And you are in the best hospital. You should see the others. Misery upon misery.

SALIM tries to shift in his seat. He winces.

MARWAN: Is it hurting badly?

SALIM: I'll live. It's just that I'll have to give up my dream of becoming a ballerina.

KATHUM: Salim…unfortunately Swan Lake had to be cancelled this year.

SALIM laughs.

SALIM: So who did you vote for ostath Kathum [Mr Kathum]?

KATHUM: Ah, it's my democratic right not to tell you.

MARWAN: I watched it on TV. The craziest election I ever saw. People made their way through roadblocks and queued to vote at great risk.

KATHUM: Don't forget the polling station that was bombed.

MARWAN: The survivors asked for the corpses and the mess to be cleared so they could go on voting.

KATHUM: It's true, it happened.

MARWAN: But then what kind of democracy is this; when the voting form is the size of a tablecloth and you can't recognise half the party names on the ballot?

KATHUM: Half is generous. Still, it was the start. It's a bloody mess but there is room for optimism.

SALIM: Not for long. We had it... No, I...I had it all wrong.

MARWAN: (*Glancing towards KATHUM then back to SALIM.*) What happened to you Salim?

SALIM looks intently at MARWAN. He gets up. KATHUM offers to help but SALIM refuses his help. He walks up to the locker and begins to take out his clothes and puts them on.

Will you tell us?

SALIM: I fell off the truck.

KATHUM: When?

MARWAN: After the missile had struck?

SALIM: No, before.

MARWAN: Before?

SALIM: Never dance on a truck with half a litre of screwdriver inside you.

MARWAN: Then what happened?

SALIM: Mind you had I not fell...

MARWAN: Salim.

SALIM: Vodka and orange saved my life. Huh, I never thought of it that way before.

MARWAN: Salim, where have you been all this time?

Pause.

SALIM: I am not sure you're going to believe me.

MARWAN: If not us, then who will?

Salim Fine. (*To KATHUM.*) Promise me you won't print any of this.

KATHUM nods.

At this point SALIM has finished dressing. He is wearing his wedding suit but it is dirty and torn.

SALIM: It all started in a ditch.

NADIR enters and carries him away.

SCENE 4

November 2004. An isolated house somewhere between Habbaniya and Fallujah.

SAYEF is sitting at a table cleaning his machine gun. Next to him is an open can of Coca Cola. The door opens. NADIR enters. He is carrying the unconscious body of SALIM, which he dumps down on a mattress. He stretches, yawns then notices the open Coke can. SAYEF watches him the whole time.

NADIR: Can I have a sip?

SAYEF: Who the fuck is that?

NADIR: I found him in a ditch by the highway. Can I have a sip?

SAYEF gets up and approaches SALIM.

SAYEF: And you decided to bring him here? What's the matter with you?

NADIR: What was I supposed to do, just leave him there?

SAYEF: No. You should have shot him then left him there. Is he alive?

NADIR: Well he was breathing.

SAYEF kicks SALIM in the stomach.

SAYEF: Gooom! [Get up!]

SALIM is jolted out of his unconsciousness. SAYEF kicks him again.

Who are you?

SALIM begins to moan. SAYEF delivers another kick.

I asked you a question!

NADIR: Take it easy Sayef. Look at his leg; it's all bloody and bruised. I think his ankle might be broken.

SAYEF: Are you sure?

NADIR: Well I'm no doctor, am I? But look at it.

SAYEF: One way to find out.

He kicks SALIM in the leg. SALIM bellows out a tremendous scream.

I think you're right.

SAYEF walks over to his machine gun on the table, picks it up and starts assembling the last few pieces.

Let's shoot the bastard and put him out of his misery.

NADIR: No!

SAYEF: Since when do you issue orders?

NADIR: I don't think you should shoot him.

SAYEF: You are an idiot, bringing stray dogs like him here. Now get out of the way or I swear I'll shoot you before I shoot him.

NADIR: We should wait for Ibraheem.

They look intently at each other. SAYEF puts down his weapon on the table.

SCENE 5

SAYEF and NADIR are playing cards. SALIM is in the corner of the room, moaning from the pain. SAYEF takes sips from a beer can in front of him whilst smoking a cigarette. He takes off one of his shoes and hurls it at SALIM.

SAYEF: I said shut it!

NADIR: You're more accurate than my mother.

SAYEF: I taught your mother everything she knows.

NADIR: Don't go there.

SAYEF: That's why your father walks around the village with that idiot's grin.

NADIR: I swear –

SAYEF slams down the cards. NADIR has lost.

Damn!

SAYEF starts to clap and shake his shoulders in triumph. IBRAHEEM enters but is unnoticed by them.

SAYEF: Hatha al yom el chena in-reeda! Hatha al yom el chena in-reeda! [This is the day that we wanted!]

He keeps repeating this common celebratory chant, often used at football matches, and clapping, becoming louder and more triumphant with each repetition.

NADIR: (*Pointing to the beer can.*) I'd put that away if I were you. Ibraheem doesn't like this shit.

IBRAHEEM: Good evening.

SAYEF and NADIR scamper to put the cards and beer away.

NADIR: (*Saluting.*) Good evening, sayidi [master].

IBRAHEEM gives SAYEF a rebuking look. SAYEF puts out his cigarette and salutes.

IBRAHEEM: Help me bring the boxes from the truck. We'll need to go through everything. Have you heard from the city?

SAYEF: Us? Why would we hear anything? They only talk to you ostath Ibraheem.

IBRAHEEM: They haven't been in touch? I just thought. Doesn't matter. Bring the boxes and then I'll give you your pay.

SAYEF: It's happening?

IBRAHEEM: They will be coming and we will hit back hard. Our brothers need to get the ammunition before the Americans enter Fallujah.

NADIR: Are we going with you?

IBRAHEEM: Yes.

Noticing SALIM in the corner.

Who is this?

SAYEF: Nadir found him on the highway…and decided to bring him here. Nothing to do with me.

IBRAHEEM: Brother Nadir?

NADIR: Yes sayidi. I thought he was dead but actually… actually he wasn't.

IBRAHEEM walks up to SALIM as NADIR is finishing the sentence. SALIM flinches and hides in the corner.

IBRAHEEM: I am not going to hurt you.

There is a look of recognition on IBRAHEEM's face. He then notices SALIM's bloody foot and begins to examine it.

IBRAHEEM: It's broken. Did you know that?

SAYEF: Yes sayidi, we noticed it. (*Pause.*) We weren't sure what to do.

IBRAHEEM: So you just left him like this?

NADIR: Shall we take him to hospital? Is that what you want us to do?

IBRAHEEM: No. Not a good idea. We'll get Adnan. Adnan could fix it.

SAYEF: Sayidi, should we be wasting valuable resources on a stray dog? I think we should just –

IBRAHEEM: Don't!

Then leaving SALIM's side he walks up to the NADIR and SAYEF and gathers them away. SALIM listens intently.

With all respect brother Sayef don't think. You are not good at it. Nadir, wipe that smirk off your face. You also did not think before bringing this man here at such a time. As it happens you did the right thing.

NADIR: I did?

IBRAHEEM: This man is from a very wealthy Baghdadi family.

SAYEF: He looks like he was going to a wedding, dressed like that.

IBRAHEEM: He was the groom. The Americans attacked them.

NADIR: Poor bastard.

SAYEF: More reason to shoot him and put him out of his misery.

IBRAHEEM: We're doing no such thing.

SAYEF: It's too dangerous to keep him here. What if his people are looking for him?

IBRAHEEM: Brother Sayef, if a sheep, a stray sheep, walked into your backyard, the backyard of the house where you and your family live, if a sheep just walked in, by some miracle of God, what would you do? Your children need food; your wife hasn't seen a new dress in years, what would you do?

SAYEF: Cut its throat and feed everyone.

IBRAHEEM: Brother Sayef, you must fatten it. You make the sacrifice to feed it until it is big and chubby then you take it to the market and sell it. Sell it to the highest bidder. This way your children get to eat and your wife has her new dress. Do you see what I am driving at?

NADIR: You lost me, sayidi.

IBRAHEEM: We keep him here for a while. Give his family a chance to mourn. Maybe we keep him till after the arba'ienia. That's when the pain of loss really kicks in.

NADIR: True.

IBRAHEEM: Then we contact his family and demand a good price.

SAYEF: And if they don't pay?

IBRAHEEM: They'll pay. They can afford it. And if they don't, our brothers from over the border might be interested in him.

SAYEF: In that case, I think he'd prefer we shoot him.

IBRAHEEM: I don't like dealing with them either. I told you this before, we don't need any outsiders to fight our war but not everyone sees things my way.

SAYEF: And if the mujahideen are not interested?

NADIR: You just want to shoot him!

Darkness.

SCENE 6

Several days later.

SALIM is now sitting up on the mattress. His foot is in a cast. He looks better. IBRAHEEM is finishing his prayer. He puts away the prayer mat.

IBRAHEEM: How are you doing brother Salim?

SALIM: I am better. Thank you.

IBRAHEEM: Soon your foot will heal.

SALIM: Then I can go home?

IBRAHEEM: If God wills it, my brother.

Silence.

SALIM: May I have a look?

IBRAHEEM looks at the Qur'an beside him.

IBRAHEEM: The Qur'an?

SALIM: Yes.

IBRAHEEM quickly exits.

(*To himself.*) Oh fuck! What did I say?

(*Shouting so that IBRAHEEM might hear him.*) Look, it's alright…really. Don't put yourself out. (*To himself.*) Fuck!

IBRAHEEM returns with a large bowl of water, which he sets before SALIM.

IBRAHEEM: Go ahead.

SALIM has a what-the-fuck-do-I-do-now? look on his face.

KATHUM and MARWAN are listening to SALIM's account throughout. They could be on stage while the story unfolds or sit amongst the audience when not needed.

KATHUM: (*Whispering.*) It's for ablution.

SALIM: Ablution! Exactly! It came to me like a thunderbolt.

KATHUM: You've been away too long.

SALIM starts using the water.

SALIM: I had forgotten that a Muslim must be clean before handling the Qur'an. I tried to remember how my grandmother used to do it.

Realising that SALIM is largely improvising, IBRAHEEM might decide to show him how some of the steps ought to be performed. SALIM finishes the ablution ritual; IBRAHEEM hands him a towel. SALIM dries his hands and face. IBRAHEEM then gives him the Qur'an before exiting.

SALIM starts to read. Enter NADIR and SAYEF. They have brought food with them. They sit huddled on the floor away from SALIM and commence eating. They are eating a leg of lamb with rice.

Reading the Qur'an had a calming effect on me.

SAYEF cuts big chunks of the meat with a carving knife and stuffs it in his mouth using his hand.

It gave me something to do and it was a good way of avoiding eye contact.

SAYEF: Look at that gawad* [pimp], he is reading the Qur'an now.

SALIM: I know how irrational this sounds, how utterly superstitious, but at the time I thought reading the Qur'an had a protective effect.

NADIR: Leave him alone.

SAYEF: He is a sly bastard, that one.

SALIM: I felt that as long I kept reading it, I might just survive another day.

NADIR: It wouldn't do you any harm to read the Qur'an every now and then.

SAYEF: Shut up and eat.

SALIM: I wish I could tell you reading the Qur'an had a profound effect on me but in all honesty I can't. God in the Qur'an is either busy forgiving people or busy condemning them.

SAYEF walks up to SALIM, still chewing on food with meat in one hand and the carving knife in the other.

SAYEF: You're fooling no one.

SCENE 7

Night time. NADIR and SAYEF are asleep. IBRAHEEM is reading verses from the Qur'an to SALIM. He finishes and closes the book.

IBRAHEEM: Saddaqa Allaho al-atheem†. [And God, the Great, spoke the truth.] Would you like me to explain the sora [chapter] to you brother Salim?

SALIM: No thank you. I understood that one. (*Pause.*) May I ask you something?

IBRAHEEM: Itfathel. [Go ahead.]

SALIM: Aren't you afraid of death?

* A common insult in Iraq.
† This is said when one reaches the end of a chapter in the Qur'an.

IBRAHEEM laughs quietly.

IBRAHEEM: I'd like to say no. Don't get me wrong. I know in my heart I will go to heaven when this is all over but still…

SALIM: You know the Americans can't allow you to win.

IBRAHEEM: God decides everything. Not the Americans.

SALIM: Doesn't God help those who help themselves? Didn't the prophet say –

IBRAHEEM: Peace be upon him.

SALIM: Didn't the prophet, peace be upon him, negotiate a truce with his enemies in Mecca?

Pause.

IBRAHEEM: Let me tell you something: our elders in Fallujah thought they were being clever when they invited the Americans. They thought they'd avoid violence and bloodshed and keep their businesses running. That was like opening the door of your house and letting the devil in. (*Pause.*) The Americans have brought nothing but death and chaos to our lives.

SALIM: But if you carry on fighting, you'll only give them more reason to stay.

IBRAHEEM: And they'll just leave if we stop?

SALIM: They might.

IBRAHEEM: Wake up! They won't.

Silence.

In April, during the siege, the Americans placed a sniper in the minaret of our local mosque. Rana, my youngest was running back home when the sniper got her. I heard the screams from inside the house. I ran out into the street. I waved at the sniper to stop shooting. He fired two more rounds. (*Pause.*) When I got to her…her face, it was unrecognizable. I prayed to God…let her be someone else's daughter. (*Pause.*) But you see…she had this birth

defect…right here… (*Indicates.*) Her lower rib protruded out a little more than it should.

Silence.

We couldn't reach the cemetery that day. We had to bury her in our garden like a dog. (*Pause.*) Once you lose your dignity, like our Palestinian brothers, you can't get it back without a fight.

SALIM: I am sorry for your loss.

IBRAHEEM: With God's help we'll make them sorry for setting foot in Iraq.

SALIM: But that means more innocent people, like you daughter, will –

IBRAHEEM: The innocent will go to heaven. (*Pause.*) The guilty, we shall dispatch to hell. (*Pause.*) Tomorrow, I'll be rounding up all my men and heading back into Fallujah. (*Pause.*) You'll be looked after by one of my sons. With God's help, we'll make it back.

Gunfire is heard. NADIR and SAYEF wake up. SAYEF looks out of the window.

What's going on?

SAYEF: Al-Amrekan. That's what's going on. Everyone get down!

They all lay flat on the floor. A hail of gunfire pierces the house.

NADIR: Allah yoster! Allah yoster! [God protects!]

The gunfire stops. IBRAHEEM gets up and runs to one of the boxes. He cranks open the lid and takes AK-47 machine guns. He throws one each to NADIR and SAYEF and takes one for himself.

IBRAHEEM: Let's get up on the roof. We can get them from there.

IBRAHEEM, NADIR and SAYEF exit. The sound of gunfire exchange is heard with varying intensity. Then a blast is heard. The room

fills with smoke. AMERICAN SOLDIERS enter. They are fully armed with machine guns. The aim-guiding laser from the guns penetrates the smoke. They walk around scanning the room. SALIM starts coughing.

SOLDIER 1: There is one moving.

He points his gun at SALIM and prepares to fire. The other SOLDIER also follow suit.

SALIM: In the name of Jesus, don't shoot!

The SOLDIERS freeze.

MARWAN enters. KATHUM enters a little later.

MARWAN waves his hand in front of one of the frozen SOLDIERS. He looks at SALIM.

MARWAN: In the name of Jesus?

SALIM: It was the first thing that popped into my head.

MARWAN: It just came out spontaneously?

SALIM: What I said worked, that's what matters.

KATHUM: So Jesus saved you.

SALIM: Or my English. Who knows?

MARWAN: (*To the SOLDIERS.*) You boys feel free to carry on.

The SOLDIERS grab SALIM and pull him up.

SOLDIER 2: Come on, get up.

SALIM: Take it easy, my foot is broken.

SOLDIER 1 starts tapping SALIM's cast.

What are you doing?

SOLDIER 1: I know the tricks you motherfuckers pull.

SALIM: What do you think is underneath there?

SOLDIER 1: Shut the fuck up.

They drag SALIM along. He is hobbling but tries his best to walk along with them.

SALIM and the AMERICAN SOLDIERS exit. KATHUM and MARWAN exit.

SCENE 8

Interrogation room.

SALIM is handcuffed. SOLDIER 1 is standing next to him. There is a desk with a comfortable leather chair behind it. On the desk there is a laptop and a phone. In front of the desk is a wooden stool. It looks tiny by comparison with the desk.

SALIM: On the way out of the house, I saw the corpses. Sayef and Nadir, all twisted and mangled in the little courtyard outside. I didn't see Ibraheem. I learnt later that he had slipped away.

KATHUM: Did you know they've been trying hard to hunt him down?

SALIM: Just wait, I'm getting to that. (*Resuming.*) So the soldiers shoved me in the back of their hummer and we drove for hours. Next thing I recall –

SOLDIER 1 pushes SALIM onto the stool.

– is finding myself in an interrogation room…and that's when I met Boothe.

Enter LT COLONEL MARK BOOTHE.

BOOTHE sits down behind the desk and slowly reclines into his chair. He eyes SALIM intently.

BOOTHE: Are you comfortable on that chair?

SALIM: It's alright.

BOOTHE: Good. I'm Lieutenant Colonel Mark Boothe and I'd like to ask you a few questions; hope you don't mind?

SALIM: No.

BOOTHE: My boys were telling me about your good English. I was intrigued. Where did you pick it up from?

SALIM: From where it originated.

BOOTHE: Sorry?

SALIM: England.

BOOTHE: Don't waste my time with irony, OK? (*Pause.*) I'm going to ask you some straightforward questions and all you have to do is give straightforward answers.

SALIM: Sure. I'll answer your questions. But we should clear one thing up first.

BOOTHE: What's that?

SALIM: What I said wasn't irony, it was sarcasm.

BOOTHE: (*Sharply.*) What were you doing in that house – the house where we found you?

SALIM: I was kidnapped. Well. Not quite kidnapped. I was heading to Habbaniya for my wedding. I don't really know what happened. Something happened. We were hit.

BOOTHE: Who hit you?

SALIM: I think you did.

BOOTHE recalls the 'wedding incident' that happened a few weeks back.

BOOTHE: OK, go on.

SALIM: That's it. I woke up with this broken ankle…in that house. I don't know what they wanted to do with me. Can I call my family? I need to know what happened to them and to my fiancée, and my friends.

BOOTHE: Your fiancée is dead. Sorry about that.

SALIM: What?

BOOTHE: Someone fucked up. It's being investigated. (*Pause.*) There're lots of questions I need to get through. Let's start with some basics, OK?

Silence.

What's your full name?

Silence.

Your name.

The SOLDIER cocks his gun.

SALIM: Salim Muhammed Abdelkareem.

BOOTHE jots down SALIM's answer.

BOOTHE: Occupation?

SALIM: Doctor. How did she die? (*Pause.*) Was it instant? Did you take her to a hospital?

BOOTHE: I really don't know. You'll get a report in the end.

SALIM involuntarily gets up.

SALIM: Please, you've got to let me use your phone.

BOOTHE: No.

The SOLDIER pushes SALIM back down onto the stool.

Where do you practise medicine?

Pause.

I don't have all day. Where do you work?

SALIM: I haven't practised for two years.

BOOTHE: Why is that?

SALIM: I was working on a novel.

BOOTHE: You really don't wanna piss me off.

SALIM: You can look it up on Amazon.

BOOTHE puts the pen down. He leans back into his chair and swivels around while lightly stabbing the tip of his index finger with a pair of scissors.

BOOTHE: If you're lying, we'll know it soon enough.

BOOTHE exits.

SCENE 9

Prison cell. SALIM's *handcuffs have been removed.*

SALIM: The first few days in the cell were like being back with the insurgents, except this time I didn't even have the Qur'an to keep me company.

He paces around.

I wondered who was kept here in the old days. Who was tortured, who was murdered? The door opened three times a day and food shoved through. I saw no one. Spoke to no one...then one day...

Enter SOLDIER 2 *carrying an old-fashioned stereo. He puts a tape in. Then he plugs his ears with wax balls before pressing the play button. The chorus of a popular rock song starts playing loudly – for example, Whitesnake's song 'Here I go again'. The* SOLDIER *exits.*

MARWAN: WHITESNAKE?

SALIM: YES, WHITESNAKE.

MARWAN: WHY?

SALIM: I WASN'T SURE AT FIRST.

MARWAN: WHAT?

SALIM: I THINK IT WAS TO SOFTEN ME UP.

MARWAN: WHAT?

KATHUM presses the stop button.

KATHUM: God, that's awful.

MARWAN: I don't get it. What was the point?

SALIM: To soften me up before each interrogation.

MARWAN: There were many?

SALIM: Same questions over and over. Not always with Boothe. Sometimes with men in civilian clothing.

KATHUM: Private contractors. The Americans use private contractors for everything, even this.

Enter SOLDIERS 1 AND 2. SOLDIER 1 pushes MARWAN and KATHUM out of the way and grabbs SALIM by the lapels.

SOLDIER 1: Come here Mr Funny Guy.

SALIM: What's going on?

SALIM slips from his grip. He tries to hobble away. The SOLDIER grabs him again.

SOLDIER 1: Come here you bastard. You thought you pulled one over us, didn't you? Playing nice…making jokes all day long…getting us to change your stinking bandages.

(*To SOLDIER 2.*) Then he turns out to be Al-KA-EDA.

SOLDIER 1 punches SALIM in the stomach.

SOLDIER 2: The fucker.

SOLDIER 1: Exactly.

SOLDIER 1 punches SALIM again. Both SOLDIERS start to beat SALIM in unison whilst hurling insults: 'Al-KA-EDA scum', 'Osama's bitch', 'sandnigger', 'deadender' etc. They drag him off stage.

SALIM: (*As he is being dragged.*) What…what…what… (*Off.*) What the fuck are you on about?

SCENE 10

Interrogation room.

SALIM has a bloody face.

BOOTHE: Does it hurt?

SALIM: What do you think?

BOOTHE: They weren't supposed to get rough.

SALIM: Ah…well…that's comforting.

BOOTHE pours SALIM some water in a plastic cup. He hands it to him.

BOOTHE: Drink.

SALIM drinks the water with difficulty then places the empty cup on the desk.

SALIM: Thanks.

Silence.

BOOTHE: Our computer pulled a seventy-eight per cent match, so I've got to ask this.

Pause.

Have you ever been to Afghanistan?

Silence.

No, I didn't think so.

SALIM: Why Whitesnake?

BOOTHE: Pardon me?

SALIM: Why do you play 'Here I go again' by Whitesnake… you know…for hours and hours on end?

BOOTHE takes out a handkerchief, reaches over his desk and hands it to SALIM. He makes a gesture indicating that SALIM ought to wipe away the blood on his face.

BOOTHE: It's just something we're trying out.

SALIM wipes the blood.

Pause.

Is it working?

SALIM: Makes me want to grow my hair long and wear leather trousers. Other than that, no.

Enter MARWAN and KATHUM.

MARWAN: Did you really say that?

SALIM: No but it would have been a good line.

KATHUM: 'Just something we're trying out.' And they wonder why we hate them.

SALIM: After that I thought: surely this was it; surely they were going to release me now. What else was left? (*Pause.*) Then a week ago he asked for me again.

BOOTHE: You know Mr Salim, the British were fond of calling your country Mesopotamia.

BOOTHE has his legs up on the desk and is stabbing his index finger with a pair of scissors.

SALIM: I thought he was being friendly at first.

BOOTHE: Meaning 'Land Between the Rivers'.

SALIM: Yes I know. (*To KATHUM and MARWAN.*) Sometimes I got the feeling he was bored and using me to pass the time.

BOOTHE: I was wondering why they insisted on this name in particular. The Brits never do anything without a reason.

SALIM: The name has a long hist–

BOOTHE: See, I have this idea. I was looking at a map of the country the other day, really focusing on it when – boom! – this image just popped into my head. Now forget the current border; just erase it out of your mind for a second.

SALIM: I think it is being erased as we speak.

Pause.

BOOTHE: So forget the border, just follow the two rivers, trace their outline, are you doing that?

SALIM: OK.

BOOTHE: What do you see?

SALIM: Two rivers pouring through Shatt al-Arab into the Persian Gulf.

BOOTHE: Wrong. It's a tight little pussy.

SALIM: What?

BOOTHE: You heard me. This is why the Mongols, the Ottomans, the Brits and now us have all wanted to stick our dicks into it, to put our mouths, our tongues into it and let its juices flow down our chins. But you know what? We were wrong. This is no sweetheart virgin. We've stuck our dicks into a whore's pussy with every goddamn dick-snapping disease under the sun.

SALIM: Why're you telling me this?

BOOTHE: Because nothing would give me more pleasure right now, Mr Salim, than to take my dick out of your country. (*Pause.*) But I have a job to do here. And I intend to do it. I need to know every snippet of conversation you heard in that house. Abraham, the man you said 'looked after you', turns out to be one ruthless son of a bitch. So let's stop pussyfooting around. I wanna know everything you can tell me about him.

SALIM: I didn't know how to react. I cared nothing for Ibraheem or his kind. Still…I felt bad to betray someone who was – at the very least – kind to me.

BOOTHE: He's not just fighting us. Yesterday twenty poor Iraqi bastards, waiting to sign up with the police force, got blown up. We believe he was behind that operation. It had his fingerprints all over it.

SALIM: I would have gladly recounted everything in a book, every last detail. I just didn't want to do it like this. In this horrid little room being interrogated by this piece of –

BOOTHE: Shit. You'll be standing in a tub of shit. Eight hours a day from now until you talk. You think you can handle that?

SALIM lowers his head then shakes it.

BOOTHE exits.

KATHUM: This is all in the past Salim. You did what you have to do. Anyone would have done the same. Marwan will back me up here.

SALIM looks exhausted and ashamed.

Marwan?

MARWAN: You were in a difficult position.

KATHUM: It's over. Don't give it another moment's thought. You are here. That's the main thing.

Pause.

Salim…just to be clear…who do you think he was?

SALIM looks at him with bewilderment.

SALIM: Boothe?

KATHUM: No, Ibraheem. Some say he is one of the criminals Saddam released before the invasion? What do you think?

SALIM: I can't say for certain.

KATHUM: Clearly he is high up amongst the insurgents but what was his role exactly in Fallujah?

SALIM: I don't know.

KATHUM: Do you think he has people on the inside with the police force?

SALIM: I really don't know Kathum.

KATHUM: Well…what did you tell the Americans?

MARWAN: Kathum!

SALIM: They asked me if he mentioned certain names. I confirmed few things for them. Things, I'd heard whispered at night. I don't even know what it all meant. Do you want me to go through all that?

KATHUM: No. It's alright.

Silence.

SALIM: When I think of them now…Nadir…Sayef… Ibraheem…I think in many ways they were just ordinary Iraqis.

KATHUM: What's that supposed to mean?

SALIM: Look…whatever else they did; they were defending their little patch of earth.

KATHUM: So they are heroes now, is that what you are telling me?

SALIM: Heroes is not the word I'd use. It prevents thinking.

KATHUM: They kill Iraqis. They kill women and children. They're bloody terrorists.

SALIM: Terrorists is another word that prevents thinking.

MARWAN: Thanks for bringing me here, Kathum. I'll catch a ride with Omar.

Pause.

SALIM: Where did he disappear to?

MARWAN: Omar? Not sure.

KATHUM: Probably chatting to one of the nurses. Trying to flog her some of his mayonnaise.

SALIM: Is that a euphemism?

KATHUM: No, he over-ordered on the mayonnaise. His father got really mad. It doesn't keep and not many people are buying it. (*Pause.*) Doctor Salim, it's good to have you back. Be careful Marwan. The curfew goes on till morning.

MARWAN: I will. Thank you, Kathum.

KATHUM exits.

What's the matter? What? Look at me. There is more to it, isn't there? Did they –

SALIM: No. No. It's nothing really.

MARWAN: Tell me everything.

SALIM: On the day of my release…

MARWAN: What? What happened?

SALIM: Nothing. It was a small thing but it caused me to experience such a wave of… I've been trying to think how to put it…it was just…

MARWAN: What? Go on. What?

Silence.

SALIM: Mark called me in.

BOOTHE enters.

He had a smile on his face.

BOOTHE looks at a piece of paper in front of him.

BOOTHE: Sit down. Sit.

Pause.

I just got the fax. Everything you told us holds water. You've been of tremendous help. (*Pause.*) Even the part about you being an author turned out to be true. (*Pause.*) Actually, I knew that for a while now. I was reading reviews of your novel. Interesting subject matter. You've caused quite a furore.

SALIM: So what happens now?

BOOTHE: You're free to go.

SALIM begins to walk away.

You know what…

Pause.

The boys were thinking of giving you the full Abu Ghraib treatment but I told them you might like it.

BOOTHE winks at SALIM then waves him away.

You can go now.

MARWAN: What an arsehole.

SALIM: No he wasn't an arsehole. He wasn't just one bad apple. This guy might have been perfectly tolerable in other circumstances. He said this because he could, because he

had the power to say it, because he had the power over me and wanted me to know it.

Pause.

I've been having this daydream.

Pause.

I imagine myself forcing him down on his desk. I imagine reaching for the buckle of his belt and lowering his trousers and pants down then I spread his arse cheeks and stick it in.

MARWAN: OK Salim –

SALIM: I fuck him hard.

MARWAN: I get it.

SALIM: I pound him till his arsehole is loosened with sweat and blood. The room fills with the whiff of shit. I pound the shit inside him. And then just when he begins to think this is the worst of it, I pull my dick out of his arse, turn him around and slap the shit across his face, just smear him with it. I fuck him in the mouth, holding his pistol to his temple. He chokes on my cum, his throat filling with it. When I am done, he vomits…vomits all the bile inside him…bile mixed with cum.

MARWAN: Calm down. Please.

SALIM: I reach for the scissors on his desk, the ones he kept playing with while interrogating me, and stab him in one eye. The eyeball is mashed and scooped out like a cracked egg from a carton. And after this carving, when there is sufficient space, I fuck his empty eye socket.

MARWAN: Christ.

SALIM: I leave the other eye so he could still see what is happening to him. I have him languish in a cell, only to be brought out for more rape and humiliation. It gets to the point where he takes it, takes it and likes it because he knows no other life.

Silence.

MARWAN: I'm sorry, Salim. I'm sorry he got to you.

Pause.

SALIM: No.

Silence.

He didn't.

Silence.

It's just…

Pause.

It's just something I'm trying out.

Silence. BOOTHE might exit at this point.

Can you fetch my cigarettes?

MARWAN takes a while to register the question.

They're over there.

He looks at where SALIM is pointing. He picks up the pack and the lighter.

Light one for me.

MARWAN takes the last cigarette from the pack. Lights it up, takes a breath, coughs. He hands the cigarette to SALIM.

You don't smoke, do you?

MARWAN shakes his head. SALIM takes a big breath. MARWAN crumples the pack and throws it in a bin.

Is it finished? Oh, I forgot to tell you. You know who came to see me first night I was here?

MARWAN: Who?

SALIM: Luma. Do you remember Luma?

Pause.

MARWAN: What about her?

SALIM: You're going to think I've gone mad…or perhaps you'll understand.

Blackout.

SALIM and MARWAN exit.

SCENE 11

Same night. LUMA's surgery at the hospital. A basin and a mirror are in one corner of the room. There is a desk with an emergency lamp, a chair and a trolley with medical equipment. Sound of patients in the corridor outside could be heard throughout this scene. The blackout is continuing.

Optional: a hospital porter could walk amongst the audience, shining a light in their faces and calling out the name of a patient. Other patients could be standing in the aisle, demanding to be seen. Finally the porter finds the patient he is looking for and guides him to the stage. LUMA enters and exchanges a few introductory lines that lead up to the dialogue below. The lines could be improvised by the actors.

LUMA examines the eye of the patient with a small torch light. The patient is a MAN in his forties with a bandaged head, wearing a dishdasha. The bandages are bloody. He is fidgeting and blinking.

LUMA: Hold steady.

Pause.

You know, you're lucky.

MAN: Lucky.

LUMA: You can really examine the eye in the darkness. No distraction. Usually the generator kicks in straight away. I don't know what's happening tonight.

MAN: What do you see?

Pause.

LUMA: There is a tiny fragment of glass.

MAN: (*Alarmed.*) Glass?

LUMA: Tiny. Just below the cornea.

MAN: Am I…am I going to go blind?

LUMA straightens and heads towards the table behind her to light a charged neon lamp.

LUMA: Not tonight.

She takes the lamp in one hand and drags a trolley with medical instruments to where the MAN is sitting.

There. Hold it tight.

She hands the MAN the lamp. He takes it with his left hand.

Up. Up.

The MAN raises his arm accordingly.

Now when I tell you, I want you to look up and to the right. Not yet. When I tell you.

She takes out a pair of fine medical tweezers that were wrapped in sterile gauze. She clicks her fingers – or stomps her foot. The MAN does as instructed. Swiftly she goes for the piece of glass and removes it.

Done.

MAN: I didn't feel a thing!

LUMA: I get plenty of practice.

She takes the lamp from him and puts it back on the desk. She also puts away the trolley.

MAN: Thank you doctora! Thank you. I am in your debt.

She makes a gesture to say it was nothing.

What a god-awful night.

LUMA: How near were you?

MAN: Just on the other side of the road. Bastards. Murdering bastards.

LUMA: They are keen on keeping us busy.

MAN: The blast wasn't the worst of it. It was the thud, just above my head. Sounded like a football. Like some kids

had kicked a football against the wall. Then it dropped and rolled till it was between my feet. A head…with empty sockets, a boy perhaps, I'm not sure. I looked down and panicked. I was bleeding over it. (*He touches his bandaged head.*) God, the panic! I thought that was it.

LUMA: You'll be…

The MAN begins to cry.

MAN: Forgive me.

LUMA: Tears are good for the eye.

She writes him a prescription.

You can't let it get infected.

She hands him the prescription.

MAN: God save you doctora.

MAN exits.

LUMA heads towards the basin. Turns on the faucet. The water doesn't come on at first. The faucet then groans as if it is coughing up phlegm rather than water. LUMA washes her face. Turns off the faucet. The sound of distant gunfire jolts her.

MARWAN enters, LUMA doesn't notice him. Lights come back on.

LUMA: (*Blinking.*) Marwan! What are you doing here? It's the middle of the night.

MARWAN: (*Darts a glance to the ceiling.*) I was upstairs. Visiting Salim.

LUMA: Oh. He didn't say. He didn't say you were coming.

Silence.

MARWAN: (*Calmly.*) Why didn't you tell me?

Silence.

Why did I have to hear it from him?

LUMA: I'm sorry. I'm so sorry, I should have.

MARWAN: When I woke up and saw you had gone I thought you regretted our night together…but then I read your note; it left a different impression. (*Pause.*) I wanted to give you space to think. Did I do wrong?

LUMA: No. That was thoughtful.

Pause.

MARWAN: Go on.

LUMA: I can't go back to London. I'm sorry. You learn to expect the worst from the Americans but England –

MARWAN: That's not the reason is it? (*Pause.*) I am having a very hard time (*Pause.*) hard time comprehending what Salim just told me.

Silence.

He proposed. And you accepted?

She nods, not looking directly at him.

LUMA: The minute I walked into his room and saw him sleeping, the minute I crossed the threshold, I thought if he opened his eyes, if he spoke to me, I'd forgive him everything. I couldn't tap into the bad any longer. I only remembered how good it was between us. How passionately we – (*She stops having registered the hurt look on* MARWAN's *face.*)

MARWAN: What have I been for you?

LUMA: (*Tenderly.*) Marwan for you I feel…

MARWAN: The just-in-case guy. Is that it?

Pause.

I love you.

LUMA is taken back by this.

Do you have any idea what that means? I have ached for you all these years! Since the cursed day I met you at his fucking party –

LUMA: (*Overlapping.*) Lower your voice.

MARWAN: (*Overlapping.*) – when he was screwing anything that moved –

LUMA: (*Overlapping.*) – I'm a divorced woman. People here –

MARWAN: (*Overlapping.*) – right under your nose.

LUMA: (*Overlapping.*) – gossip as easily as they breathe.

MARWAN: (*Overlapping.*) Don't you have any self-respect?

LUMA: This is the past, Marwan. I can't believe you could be this judgemental. (*Pause.*) You're supposed to be his best friend.

MARWAN: I came back to this fucked up country because he asked me to. (*Pause.*) I am glad he is alive, very glad…but there is something you have to realise about Salim. He has about as much of a connection left with this place as I do. He came back because he smelled a good story, the story he was gearing up to write and now…now, he has it. That's who Salim is. I love him but that's who he is.

LUMA: Marwan, that's not true. He's changed. Someone else would have been on the first –

MARWAN: (*Thinking of SALIM's heroic adventure, he spits out this imperfect analogy.*) Captain Corelli without the fucking mandolin.

LUMA: Plane out. What?

MARWAN: You know what's changed?

LUMA: He wants to stay.

MARWAN: Zina is dead, that's what's changed.

LUMA: Despite everything he's been through, he wants to stay.

MARWAN: You're making another mistake.

Pause.

I know you feel something for me.

LUMA: Marwan, you're a great man but you don't belong in Iraq.

MARWAN: Neither do you. This country is finished.

LUMA: I refuse to believe that.

MARWAN: Can't you see? It's a turd…floating in a bowl, begging to be flushed.

LUMA: Tell that to the people outside.

Walks up to him and drags him by the lapel to the door.

There's a thirteen-year-old girl with an amputated leg sitting out there. Go tell her that. Go.

He grabs her hand.

MARWAN: Come back to London with me.

She pulls away.

LUMA: This is where Salim and I are staying…in this place, in this fucked up place. Salim wants to be here. He wants to work as a doctor again.

MARWAN gives her a look of incredulity. She comes closer to him.

And write, yes. Someone needs to scream at the top of their lungs about what's happening.

MARWAN: What good will that do? No really, tell me. You think the problem is a shortage of words? Half the Amazon forest has gone into writing about Iraq. (*Pause.*) A maniac could walk in here one day and gun you down…all because you are no longer wearing the veil. Married or not.

LUMA: That's not going to happen. I know how to protect myself.

MARWAN: Luma, they're targeting us now. The educated, the independent-minded. It's madness to stay.

LUMA: So we just run away; that's your solution? Retreat to England; live the rest of our days in exile, pining for every inch of this land?

MARWAN: We didn't ask for this! (*Pause.*) Tell me you feel nothing for me. Tell me that and I'll go away.

LUMA hesitates, draws nearer to him, then kisses and hugs him.

LUMA: (*Whispering.*) Of course I can't.

Silence.

MARWAN: I've looked for you in every girlfriend I've had.

Tears begin to fall from her eyes.

In the end, Salim will hurt you. You know that.

LUMA: He…he was my first love.

Pause.

MARWAN: And you were mine.

MARWAN and LUMA exit.

SCENE 12

The Wedding / MARWAN's departure.

MARWAN is sitting alone at one of the wedding guest's tables. He is dressed smartly, perhaps too formally. Arabic music is blaring. Disco lights are reflecting across his face. He is looking in the distance. KATHUM enters and sits huffing on a chair opposite MARWAN. The music becomes quieter so that their conversation is audible.

KATHUM: Why aren't you dancing?

MARWAN looks at KATHUM but doesn't say anything.

I'm sweating like a bitch. (*He picks up a napkin and wipes his face and neck.*) Look at Omar. Look at him. He looks so ridiculous. Zero hands and feet coordination.

MARWAN: It's nice when you lose yourself like that.

KATHUM: He'll regret it when he'll see himself in the wedding video.

Silence. KATHUM puts down the napkin. He looks in the distance at where MARWAN is looking.

They look great, don't they?

Silence.

Who would have thought things would turn out this way. We had the wedding after all. So you see…your trip to Iraq wasn't such a waste.

Silence.

You alright?

MARWAN: I'm just a little tired Kathum.

KATHUM looks at him for a while. He then gets up and starts to walk away, then stops and looks in the distance.

KATHUM: It's good to see her so happy.

He looks back at MARWAN.

Only in stories can a wedding be the end. In life, that's never the case. You can't tell how things might turn out.

KATHUM exits.

The music fades completely. MARWAN gets up and approaches the front of the stage.

MARWAN: (*To the audience.*) The night before my departure, I went up on the roof of our house. Hardly anyone sleeps on the rooftop anymore. People are afraid a stray bullet will make their sleep permanent.

I laid down on a mattress and looked up at the sky. Luma was right. This is the most gorgeous night view imaginable. Maybe the stars were not as bright as I once remembered but they were dazzling still. Sleep came soon and then a dream. At first I thought I was having the UFO dream, the dream of my childhood summers. Something descended from the sky but it was not a spaceship. What came down

was a dark, ominous temple. I walked up the steps and crossed into darkness. It began to rain. Hands reached out to bathe me. I tried to open my eyes but I couldn't. I heard murmurs, prayers, felt a cloth upon my face. My entire body was being bound in a shroud. The white shroud for burial.

'Baghdad', the song that opened the play is heard, faintly at first.

When I opened my eyes again, the rooftop had turned golden with daylight. A gecko darted soundlessly across the tiles. In the distance, a palm tree shook off handfuls of dust. I knew these would be amongst the last images I'd be taking with me.

There is one other image.

SALIM and LUMA enter. They are dressed as bride and groom. They begin to dance.

That above all reminds me of what I left behind:

A country found, then lost again.

When I remember it, my mind is sent reeling,

Falling through space like a stone

And my heart,

My heart catches.

Darkness.

The End.

Iraq Timeline

1979 **16 July** – President Al-Bakr resigns and is succeeded by Vice-President Saddam Hussein.

1980–8 Iran-Iraq war.

1988 **16 March** – Iraq is said to have used chemical weapons against the Kurdish town of Halabjah.

1990 **2 August** – Iraq invades Kuwait and is condemned by United Nations Security Council (UNSC) Resolution 660 which calls for full withdrawal.

6 August – UNSC Resolution 661 imposes economic sanctions on Iraq.

1991 **16–17 January** – The Gulf War starts when the coalition forces begin aerial bombing of Iraq ('Operation Desert Storm').

24 February – The start of a ground operation which results in the liberation of Kuwait on 27 February.

3 March – Iraq accepts the terms of a ceasefire.

Mid-March / early April – Iraqi forces suppress rebellions in the south and the north of the country.

1993 **27 June** – US forces launch a cruise missile attack on Iraqi intelligence headquarters in Baghdad in retaliation for the attempted assassination of US President George Bush in Kuwait in April.

1995 **14 April** – UNSC Resolution 986 allows the partial resumption of Iraq's oil exports to buy food and medicine (the 'oil-for-food programme'). It is not accepted by Iraq until May 1996 and is not implemented until December 1996.

1996 **3 September** – US extends northern limit of southern no-fly zone to latitude 33 degrees north, just south of Baghdad.

1998 **31 October** – Iraq ends cooperation with UN Special Commission to Oversee the Destruction of Iraq's Weapons of Mass Destruction (Unscom).

16–19 December – After UN staff are evacuated from Baghdad, the US and UK launch a bombing campaign, 'Operation Desert Fox', to destroy Iraq's nuclear, chemical and biological weapons programmes.

1999 **17 December** – UNSC Resolution 1284 creates the UN Monitoring, Verification and Inspection Commission (Unmovic) to replace Unscom. Iraq rejects the resolution.

2001 **February** – Britain, US carry out bombing raids to try to disable Iraq's air defence network. The bombings have little international support.

2002 **September** – US President George W Bush tells sceptical world leaders at a UN General Assembly session to confront the 'grave and gathering danger' of Iraq – or stand aside as the US acts. In the same month British Prime Minister Tony Blair publishes a dossier on Iraq's military capability.

November – UN weapons inspectors return to Iraq backed by a UN resolution which threatens serious consequences if Iraq is in 'material breach' of its terms.

2003 **March** – Chief weapons inspector Hans Blix reports that Iraq has accelerated its cooperation but says inspectors need more time to verify Iraq's compliance.

17 March – UK's ambassador to the UN says the diplomatic process on Iraq has ended; arms inspectors evacuate; US President George W Bush gives Saddam Hussein and his sons 48 hours to leave Iraq or face war.

20 March – American missiles hit targets in Baghdad, marking the start of a US-led campaign to topple

Saddam Hussein. In the following days US and British ground troops enter Iraq from the south.

9 April – US forces advance into central Baghdad. Saddam Hussein's grip on the city is broken. In the following days Kurdish fighters and US forces take control of the northern cities of Kirkuk and Mosul. There is looting in Baghdad and elsewhere.

May – UN Security Council backs US-led administration in Iraq and lifts economic sanctions. US administrator abolishes Ba'ath Party and institutions of former regime.

14 December – Saddam Hussein captured in Tikrit.

2004 **March** – Suicide bombers attack Shia festival-goers in Karbala and Baghdad, killing 140 people.

April–May – Hundreds are reported killed in fighting during the month-long US military siege of the Sunni Muslim city of Fallujah.

Photographic evidence emerges of abuse of Iraqi prisoners by US troops.

June – US hands sovereignty to interim government headed by Prime Minister Iyad Allawi.

November – Major US-led offensive against insurgents in Fallujah.

2005 **30 January** – An estimated 8 million people vote in elections for a Transitional National Assembly. The Shia United Iraqi Alliance wins a majority of assembly seats. Kurdish parties come second.